Remarkable Women

of

Sanibel
& Captiva

Remarkable Women
———— of ————
Sanibel
& Captiva

JERI MAGG

To Brenda,
Enjoy your stay
on Sanibel,
Jeri Magg

THE
History
PRESS

Published by The History Press
Charleston, SC
www.historypress.net

Contents

Acknowledgements

As any author knows, without the help of others, editors, researchers, librarians and other historians, my book would not have been completed. Betty Anholt, Ann Bradley and Deb Gleason knew the facts and were ready to share them.

My docent friends at the Sanibel Historical Museum and Village offered encouragement. Special thanks to Martha Jeffers, who trudged through the manuscript, sometimes bleary-eyed, to edit the mistakes. My gratitude also goes to Emilie Alfino, manager of the Sanibel Historical Museum and Village, who waded through the manuscript checking all the facts. These words of thanks would not be complete without a posthumous tribute to Manfred Strobel, my photographer for my first book. Many of the photos in this book are also his. I am sorry that he did not have a chance to read my second book, too.

And lastly, special gratitude and love go to my husband, Karl, who supports my efforts in all causes, even when he spends more than six months as second banana to my manuscript.

The Calusa Women

Throughout the ages, women have been the subject of love poems or the muses for artists or even the causes of wars. However, more times than not, their influence has had a stabilizing effect that calmed the chaos and eventually ensured that a civilization endured. There are exceptions, but it is fair to say that were it not for women, man would have run amok long ago. This analogy can be made in part when discussing the strong female influence on the histories of Sanibel and Captiva Islands.

Historians believe the Calusa are the first inhabitants, arriving around AD 500. Controlling the west coast of Florida south of Tampa Bay, these natives were attracted by oyster bars, fish, turtle and other food sources. Before long, Calusa were settling in the oldest part of Sanibel near the exit from J.N. "Ding" Darling National Wildlife Refuge. Archaeologists have found Indian artifacts in this area dating back 2,300 years.

Present-day Sanibel, Captiva, Pine Island, Fort Myers and Estero were the heart of the Calusa territory. The capital was said to be Mound Key, then known as Calos, on the east side of Estero Bay. At the height of their culture, almost twenty thousand natives inhabited the area. They didn't farm, preferring to hunt and fish. The men were excellent sailors and fierce fighters. They didn't scalp their enemies but beheaded them instead, which made a bigger statement.

Caloosahatchee means "river of the Calusa," which served as the main highway inland for the Calusa Indians. They canoed down the river into Lake Okeechobee to access other tribal areas by way of the Kissimmee River.

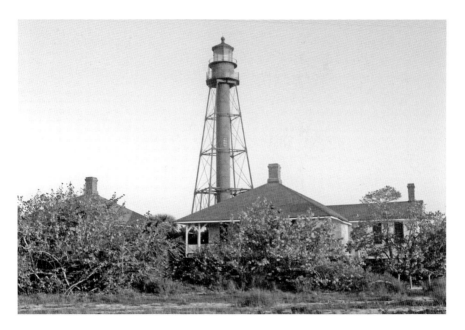

Sanibel lighthouse and cottages. *Photo by Manfred Strobel.*

What we do know about the Calusa comes from a study of the shell mounds of some of the forty villages that spread south along the Gulf coast, such as the 240-acre site at Pineland, the Calusa capital.

Historical accounts tell of the Spanish arrival in San Carlos Bay in the early 1500s. Eager to acquire land, gold and slaves for the crown, they captured Calusa women as prizes. Ponce de León wanted to impress the king and queen with his success in conquering the natives, characterizing them as easy to tame. Though able to sell this false tale to gain more funds for a return voyage, he and other explorers would pay dearly for not realizing the ferocity of these native warriors.

JUAN PONCE DE LEÓN MEETS THE CALUSA INDIANS

While Juan Ponce de León was searching for Bimini, where he believed the fabled fountain of youth was located, he discovered Florida. He sailed north along its coast for several days until he realized that what he had actually found was not an island but an unknown mainland. Several days later, he landed near what is present-day St. Augustine.

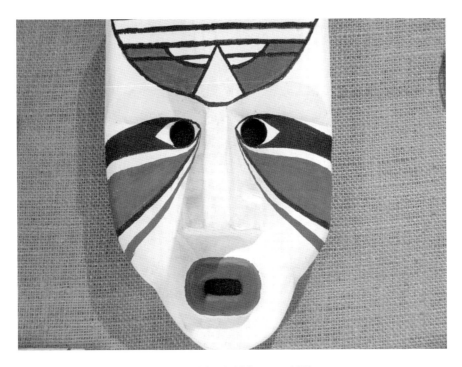

A Calusa Indian mask. *Courtesy Sanibel Historical Museum and Village.*

He went ashore and claimed the land for the king of Spain, naming it Pascua Florida (Feast of Flowers) since he found it during the Easter season. Continuing his journey south, he rounded the Florida Keys and hugged the coastline northward.

Once parallel with Captiva, he entered Pine Island Sound and dropped anchor off the west coast of Pine Island. There, his crew spent ten days cleaning the hull of his ship, gathering firewood and filling their water barrels. As they were pulling up anchor, the Indians attacked. The sailors became so angry they chased the Indians to shore and captured four women. This action subdued the Calusa for a while, but it would take the Spanish almost fifty years before they realized the Indians would never be conquered.

Ponce de León spent twenty-one days in the bay area before understanding that he would not find the fountain of youth. He then ordered his ships to pull up anchor and sailed southeast to Puerto Rico.

In 1521, Ponce de León returned to the area with two hundred settlers, cattle and building materials. The Calusa, remembering his earlier voyage, watched in the shadows. This time, they allowed the Spaniards to rest before sneaking up on them at night and attacking. Eighty Spanish sailors died, and

Ponce de León was severely wounded by an arrow in the thigh. Though most of the attacking Indians were also killed, they still managed to demoralize the Spaniards, who weighed anchor and limped back to Cuba. Ponce de León died there after his wound became infected.

Pedro Menéndez de Áviles Comes in Peace

By 1566, when Pedro Menéndez de Áviles sailed into the bay near the island of Sanibel, the ferocious nature of the Calusa was legend.

While on board, one of his crew noticed a lone figure in a dugout canoe approaching the ship. Though dressed as an Indian, the man spoke Spanish. Once aboard, the man showed his cross and told tales about his capture and life among the Calusa. Upon hearing the story, Menéndez fell to his knees and gave thanks to God for helping him accomplish one of his objectives: to rescue the Christian captives of the Calusa.

Menéndez's last two objectives—to convert the Indians to Christianity and reclaim land held by other European countries for Spain—were still to be fulfilled. His rewards were the titles of governor and captain general of Florida.

To achieve his goal, he brought five hundred soldiers and spent months attacking and wiping out all French settlements on the East Coast. By the time he arrived in San Carlos Bay, the Calusa had heard about his exploits and were wary.

Their king, Carlos, told his followers to bide their time and pretend to befriend the conquerors. Menéndez, also suspicious of the Calusa, sent a messenger to Carlos to say that the Spanish had come in peace and bore many gifts. When Carlos arrived with three hundred warriors, the uneasy Menéndez had soldiers watching in the shadows ready to attack.

Carlos, overwhelmed by the size of Menéndez's fleet and hungry for the conqueror's delicious treats like honey and biscuits, acted submissive. He was rewarded with a great feast and an invitation to board the Spanish galleon. To keep Menéndez happy, Carlos sent men back to his village to fetch whatever captives he held.

This mistrustful cat-and-mouse game continued for more than three years.

Doña Antonia

Menéndez promised to act as Carlos's elder brother if the chief converted to Christianity. According to the expedition's historian, the savvy chief invited the explorer to a great banquet with two thousand Calusa, half of whom were beautiful women. During this feast, Carlos offered his sister in marriage. Menéndez, a devout Catholic with a wife and two children in Spain, stated that a Christian could not marry a non-Christian. Carlos, eager to trap his enemy, countered that if the explorer was Carlos's brother, then he and his sister were Christians by extension.

Menéndez had no choice but to participate in a mock ceremony. Carlos's sister and her retinue were taken back to the ship, where she was baptized Doña Antonia and dressed in European clothes.

Carlos had tents erected on the beach for a huge banquet. Afterward, the bride was escorted back to the ship, and the next morning, she informed her brother that the marriage had been consummated.

Having kept his part of the bargain, Menéndez expected Carlos to do the same. Two crosses were erected in front of the chief's palace, and Carlos agreed to worship the Spanish God—but with a caveat: he'd not give up his belief in the other gods unless there was proof it would benefit him.

Menéndez and Doña Antonia sailed south and remained in Cuba for a while, she learning the ways of Christianity, he attending to his affairs. They never lived together as man and wife while in Cuba. Menéndez then sailed for St. Augustine, promising to return for Doña Antonia in three months.

Back in St. Augustine, Menéndez found his colonists starving after fighting off a succession of Indian attacks. These settlements now fortified, Menéndez returned to Cuba with the hope that King Philip would send soldiers and supplies for the colonists.

Upon arriving, he found the governor of Cuba hostile and uncooperative. Doña Antonia had also lost some of her Indian companions to disease. Depressed, Menéndez returned to his home to confer with his friend Juan de Ynistrosa, treasurer of Cuba. Ynistrosa was concerned that the deaths of the Calusa women would make King Carlos angry. If his sister, Doña Antonia, died also, then the wrath of the Indian chief would be on all their heads. He urged Menéndez to sail back to Sanibel with Doña Antonia, while Ynistrosa promised to try to intercede with the king for more soldiers and food for the colonists.

Doña Antonia had been a quick study, learning her prayers and the ways of Spanish society. Menéndez decided to call on her the next evening,

bringing flowers and musicians, but was shocked by her response to his gifts. Hysterical beyond reasoning, she accused the explorer of shaming her in front of all Cuban society by not coming to her house upon his arrival. Believing this marriage a sham, he was surprised by her ideas. Always able to rise to the occasion, Menéndez showed the distraught woman his cross of the Order of Santiago. He stated that a knight of this order was not allowed to sleep with his wife for eight days after an encounter with his enemies. Antonia believed this fable and allowed the musicians to serenade her and accepted his gifts. Menéndez remained with her for a few hours and then returned to his own bed, convinced that his lie had worked.

But he was wrong. That evening after midnight, Antonia and three of her maids appeared at Menéndez's house and were admitted by one of his servants. Unannounced, they entered the explorer's room. Doña Antonia grabbed a candle and started searching for Menéndez's mistress, in his bed and even under it. Awake now, Menéndez demanded to know what was happening. His Calusa wife explained that others in Havana were saying he had a mistress.

She demanded to remain with him so Carlos would see they were man and wife. Then Carlos would have to become a Christian. Menéndez, almost out of options, searched for an answer. Finally, he stated that if she stayed, then God would strike him dead since he was disobeying his Order of Santiago. Antonia didn't wish to see her husband dead and left.

The following day, Menéndez, Doña Antonia and her retinue set sail for Estero Bay. Once landed, they sent word of their arrival to King Carlos. Two hours later, Carlos appeared and boarded the ship. After enjoying a banquet, Carlos was asked to cut his hair and return to Cuba for religious instruction. Carlos refused, citing the rebelliousness of his natives, but he promised to release the rest of the captured Christians. Carlos and Antonia left the ship, but no captives appeared. In the meantime, Carlos, hatching a plan to kill the explorer, asked Menéndez to join him at his home on Calos. Menéndez, learning of the chief's plot from one of his spies, refused and called Carlos a liar, stating that if the Spanish prisoners were not returned, he would order his soldiers to burn down the town of Calos and behead all the chiefs.

The next morning, the prisoners were brought back by Carlos, who then offered himself for death in exchange for his chiefs. Menéndez admired his boldness and invited the Calusa chief on board, where the two made peace once again. When the explorer sailed for Cuba the following day, he was accompanied by Doña Antonia and the twenty-year-old heir to Carlos, Don Pedro, who would also learn the teachings of Christianity.

Before leaving, Menéndez ordered Captain Francisco de Raynoso to establish the first colony on the west coast of Florida and build a fort at the Calusa capital city of Calos, now Mound Key. Carlos was not thrilled to have a Spanish fort built on the island, as his goal was always to drive the Spanish from his lands. Over the next few months, Raynoso and Father Rogel, the Jesuit priest whom Menéndez had asked to stay and convert the natives, were constantly in danger of being murdered. They sent letters to Menéndez asking for help.

Menéndez set sail for the Calusa capital with Doña Antonia in hopes that the reunion of brother and sister would ease tensions. After the siblings were united, Carlos asked Menéndez to help him war against a rival tribe, the Tocobaga, in Tampa Bay. Menéndez thought this a good opportunity to convert this tribe, too.

Upon entering Tampa Bay, the enemies of the Calusa attacked and were repelled. Carlos wanted to follow and kill them, but Menéndez sent an emissary for peace and befriended the Tocobaga instead. Carlos was furious, and Doña Antonia wanted Menéndez to destroy their pagan idols. She accused him of two hearts, one for himself and one for the Tocobaga but none for herself or her brother. No matter what the explorer said, he could never appease her, so they parted for the last time. She returned to Calos and he to Cuba. Things had come to a head. Menéndez wanted to convert the Calusa, but Carlos hatched a plan to kill the priests and then Menéndez.

When the explorer learned of this deceit, he went back to Calos. His patience now at an end, Menéndez summoned Carlos and his chiefs to meet him on shore, where he ordered them all beheaded. Menéndez, disappointed with his failure to convert the Calusa, returned to Spain. The Calusa, after burning the Spanish fort at Calos, disappeared into the interior of Florida.

Whatever happened to the Calusa? Some say they were wiped out by the Creek Indians from Alabama while others say they paddled off to Cuba and were assimilated there. But the majority of the tribe probably succumbed to European diseases. One final theory is that small groups still exist in the Everglades.

In any event, women played an important part in this early history of the area. They were either used as prize captives to show off to the king of Spain or as beautiful pawns, as in the case of Doña Antonia, who was used to lure the powerful explorer Pedro Menéndez to enter into an agreement, against his religious beliefs, to satisfy a plotting Calusa chief.

We will never know what happened to Doña Antonia, but she was one of the first women to make history in the area.

First Sightings

For hundreds of years, the waters surrounding the islands of Sanibel and Captiva remained a popular trade route and fishing area for Indians and Europeans alike. The hidden caves tucked away in the inlets around San Carlos Bay were a perfect hideout for pirates hoping to pounce on unsuspecting frigates overflowing with bounty.

SPANISH

The Spanish never stopped trying to convert the natives to Catholicism. In the late 1600s, Franciscan friars were successful in establishing missions across northern Florida. To continue this conversion, an attempt was made to enter San Carlos Bay near Point Ybel. The Indians rejected this effort by forcing two priests working on the islands to flee to the Florida Keys. Three years later, the friars tried again, this time with success. This allowed the ports along San Carlos Bay to resume trading with Havana.

Though most of the Indian natives had fled or died, those remaining showed Spanish fishermen where to fish around the islands. Many intermarried with native women, and their offspring were known as Spanish Indians. But the slave trade was still a priority.

The captains of Spanish galleons were famous for surprise raids to catch natives around Point Ybel and Captiva. For more than three hundred

years, the Indians fought against these attacks, but it was becoming a losing battle. To even the score, after the Spanish, French or English seized one another's ships and killed the crews, the island natives would capture surviving French and Spanish to ransom for their own people.

Following the French and Indian Wars, Florida was ceded to England in 1763 in exchange for the city of Havana. By now the Indians, friendly with the Spanish and fearful of the British, had fled to Cuba. However, their fears were unjustified, since the English allowed the Indians to trade as they wished. The remaining fisheries in the area prospered once more.

At the end of the American Revolution, England returned Florida to Spain, which ultimately negotiated with the Americans to rid itself of these lands. The wars in Europe and the United States would continue to make an impact on the history of the islands.

The Florida Land Company
Assesses the Islands

Sanibel

In 1819, it was still not clear who owned the Gulf Coast islands. Richard Hackley, a Virginian who was a consul in Cádiz, was in the midst of a sale for a large tract of land in the southwestern part of the peninsula. Though the tract included a defined border along the coastal mainland, its western boundary was vaguely drawn. It was assumed that the offshore islands were included. In 1831, Hackley sold an option for part of his property to a group of New York investors, the Florida Peninsula Land Company, which was planning a settlement in south Florida. The company's lack of due diligence caused it to miss the cloud over Hackley's title, and it mistakenly created fifty shares of stock, with one share equaling 1,800 acres of land. Each share originally sold for $500.

The prospective buyers had the choice of a number of different sites between Cape Roman and Tampa Bay. In 1832, their agent was sent to the area to select the best one. Impressed with the deep-water harbor in San Carlos Bay that led him into Sanibel Island, the agent proposed the creation of two towns: Murray and Sanybel. Both requested and received incorporation papers.

By the fall of 1832, Sanibel's backers had sent workmen to build five palmetto-thatched huts with floors of shell and sand that would act as

Sanibel Island today. *Photo by Manfred Strobel.*

temporary shelters. Dr. Benjamin Strobel, editor of the *Key West Gazette*, wrote stories about this project in hopes of attracting people to the area.

Influenced by his own research, Strobel decided to buy into the land company. In 1833, he boarded the vessel *Olynthus*, which was about to sail from Key West to Sanibel. Accompanied by thirty men and women from New York, the editor happily anticipated this new adventure, safe in the knowledge that another ship, the *Associate*, was following behind.

According to Strobel's accounts, the changing tides and surprise appearance of unknown sandbars around Sanibel were about to make his journey even more exciting. When the *Olynthus* was only a few miles off the shore of Sanibel, a crewman miscalculated the draft and the ship went aground on a sandbar. By three o'clock in the morning, heavy wind and surf pummeled the ship, causing water to rush across its decks and through the stern ports. The terrified passengers searched all night for their sister ship. Finally, the *Associate* caught up, and the captain sent a small boat to take most of the passengers off and drop them on the beaches of Sanibel.

Delighted to be ashore, the colonists, overwhelmed by sand fleas, prepared to live in their new homes. That evening a thunderstorm with torrential rains flooded their huts. There was no sleep for these folks; they spent the night digging a drainage ditch door to door in their houses.

At sunrise, Dr. Strobel explored the island and was pleased to find an abundance of wildlife. He was convinced the area was perfect for farming and fishing. Though Strobel and his men explored Captiva, too, all they found were a palmetto house, a few stalks of corn and some pumpkin vines in the remnants of a garden. There was no one living on Captiva, only a large number of wild hogs roaming the shores.

For economic reasons, Strobel was forced to return to his practice up north via Key West and never saw his dreams come to fruition. Because of the dispute over the ownership of the land, the onset of the Seminole Indian Wars, the need for a lighthouse and the destruction brought by hurricanes, settlers were driven from the island. The Florida Land Company went bust, and by 1844, no one lived on Sanibel.

Captiva

Captiva's beginnings are similar to Sanibel's, where Calusa Indians are presumed to be early inhabitants. Archaeologists uncovered bones in 1927 on South Seas Plantation. More than seventy skulls were discovered, some believed to be one thousand years old.

Captiva Island today. *Photo by author.*

The first white man to visit Captiva came by accident. William Binder worked as a cabin boy on a German freighter. The ship was traveling to New Orleans when a storm caused the freighter to sink off the coast of Boca Grande. Binder, unable to swim, spent days hanging on to a piece of driftwood before being carried by the currents to Captiva's shore. He remained there for a number of weeks, living on fish and wild fruit while building a small raft. He paddled to Pine Island, where the locals helped him return to Austria.

In 1888, now thirty-eight years old, he returned to the island. Because he had served in the U.S. Army and was about to become a naturalized citizen, he was able to homestead on Captiva. He lived alone for ten years in a crude palmetto-thatched hut with a dirt floor. He survived by selling off his land to eager homesteaders. Two hundred yards off Captiva's southeastern shore was the island of Buck Key, named for the large deer that frequented it. A little more than a mile long and half a mile wide, ridged with Indian mounds, this island supported the homesteads of three families.

PIRATES

Legends of pirate attacks saturate the islands. The following story was told by an old fisherman named John Gomez, who lived in the Ten Thousand Islands. A census taker in 1900 was so astounded by the tale that he retold it often enough for no one to be sure what is fact and what is fiction.

Gomez claimed to be a 125-year-old native from Madeira. He'd immigrated to Cuba, but after many encounters with the law, Gomez fled by rowboat to the Florida Keys. There he turned to thievery and became entangled with sinister men, captive women and stolen treasure. He alleged to be part of the crew of the notorious pirate José Gaspar and further claimed the island north of Captiva, Gasparilla, had been named after this pirate. No one had ever heard of such a person, but many were intrigued. And so the legend spread. Gomez died in a bizarre accident in 1900, but the story lingered. In 1923, an original account was written in Francis Bradlee's *Piracy in the West Indies and Its Suppression.*

THE CIVIL WAR AND THE HOMESTEAD ACT

The Civil War made the mostly unpopulated state of Florida part of the Confederacy. By the middle of the 1800s, Florida was a rural territory with large farms and plantations. In 1845, when Florida became a state, the population was around 140,000. Of these, 63,000 were African Americans, most of whom were slaves. The state's economy was based on cattle and crops. Slavery was practiced in Florida, but not all African Americans were slaves. Many bought their freedom or were freed by their owners. Some were Creoles, free descendants of Spanish citizens of African ancestry.

In 1842, Congress passed the Homestead Act. This allowed anyone eighteen years of age or older to farm 160 acres of land for five years and then own it. Florida also became the twenty-seventh state in the Union in March 1845.

There was no one living on Sanibel or Captiva when Florida seceded from the Union in 1861. Punta Rassa, a shipping point for south Florida, came alive with the start of the Civil War.

At first, cattlemen sold their stock to the Confederate army, but then Cubans offered to pay more. Blockade runners, such as Jake Summerlin and James McKay, became millionaires.

This blockade running came to an end when the Union army sent nine gunboats and several hundred men to police the area waters and establish a barracks called Fort Delaney at Punta Rassa. Telegraph lines were laid all the way to Punta Rassa in 1867, and Florida was readmitted to the Union in 1868.

That same year, a Connecticut Yankee planted a castor bean crop on Sanibel because castor oil was in short supply after the war. William Allen, who had noted that castor beans grew wild on Sanibel, had a lucrative business. In 1870, when the census was taken, he and son George were the only residents of the island. The pair stayed for another three years, leaving only after the devastating hurricane of 1873, which sent seawater surging across the island.

About the same time, Terevo Padilla, a commercial fisherman, had established fish camps on Sanibel and Captiva. His fishery was located by Seahorse Shops near an old well that probably served the original Sanibel settlers and the thirsty Calusas for hundreds of years.

Petitions for a lighthouse at the tip of Sanibel began in 1856. Twenty-one years later, an engineer surveyed the forty-two acres in the plat and asked that action be taken to obtain title to the land requested in 1856.

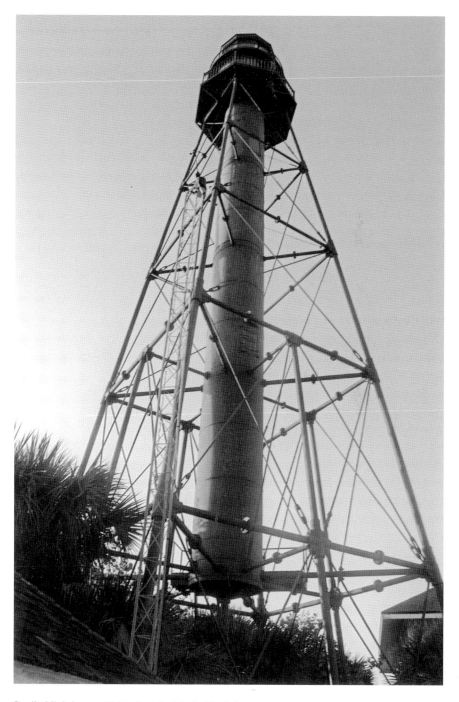

Sanibel lighthouse, 2011. *Photo by Manfred Strobel.*

After much correspondence over the following few years, a contract was signed in 1883 with the Phoenix Iron Company to furnish metalwork for the lighthouse, and it was completed in 1884. But there was a problem delivering the material to the island during a fierce storm. The following is taken from a "Report of the Light House Board in 1884":

> *Work upon this station was commenced in February when a wharf, 162 feet long, with a T-head 30 by 60 feet, was built upon creosoted piles. Material for the dwellings and the foundation of the tower was landed. The dwellings are nearly finished and the foundation for the tower completed. The iron work for the tower was shipped from Jersey City, and, when within about two miles of the Wharf at Sanibel Island, the schooner having this iron work on board was wrecked.*

After the storm subsided, crews from the tenders and working parties, along with a diver, fished up all the iron and landed it on the wharf, with the exception of two small galley brackets, duplicates of which were made in New Orleans. In August 1885, the structure was completed and lighted for the first time. This allowed ships to come safely to the island, bringing cargo and immigrants fleeing the devastation of the Civil War.

Many of these were women, widowed with children, who found themselves in desperate situations and were forced to leave their homes. Others came with their husbands after the "great freeze." And then there were those who'd heard about the beauty of the area and wanted to be part of something new.

Chapter 2

The Homesteaders Arrive

In 1894, Sanibel's population was 120 with 100 acres in truck farming. Two years later, due to post-freeze migration, the population grew to 350 with 500 acres in truck farming, and land was selling for ten to twenty-five dollars an acre.

Word spread that Sanibel and Captiva were excellent places to farm, raise families and even vacation. Churches and schools were built, and children played on beaches or paddled around the island. Farmers loaded produce on ships at Matthews Wharf for northern markets. Most prospered.

The island's beauty and the sea life convinced many of the immigrants to believe that God had planned this ideal place. An assortment of preachers and religious sects were drawn to the area.

Islanders accepted whoever brought a religious message, whether they were an itinerant preacher or the missionary Reverend George Barnes. Since the population was scattered, it was hard to communicate. Most congregants commuted to church by boat. Those who traveled by wagon bumped along sandy trails and sawgrass marshes. A few walked down paths frequented by alligators.

There was no medical care since upriver doctors had no desire to sail long hours to the islands. Homesteaders depended on one another's skills.

The hurricane of 1910 brought back the reality of living on barrier islands. Captain Will Reed described the night of October 17 in his journal: "The wind had been increasing and the bay was spilling over into a long line of breakers that rolled over the Reed dock and crashed onto

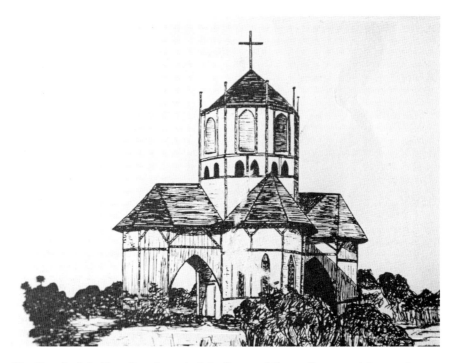

The Church of the Four Gospels was built by Reverend George Barnes and destroyed during the 1910 hurricane. *Courtesy of Sanibel Public Library.*

the beach behind it. On the Gulf side, a family watched the sea water rise around their cottage, perched on high pilings. With porches and steps gone, they were marooned."

Residents told many horror stories of surviving the storm. Fortunately, no lives were lost, but many left after their homes were destroyed.

LAETITIA NUTT AND HER DAUGHTERS: CORDIE, LETTIE AND NANNIE

Laetitia Ashmore Nutt, a Civil War widow from Louisiana, was seeking a new life for her family. After her husband died, she, her three daughters and her brother homesteaded land along the beach on Sanibel. Though a southerner familiar with entertaining elites in a lavish manner, Laetitia had no trouble picking up a hoe and digging in the dirt. Realizing that so much acreage was impossible to care for, Laetitia sold off much of

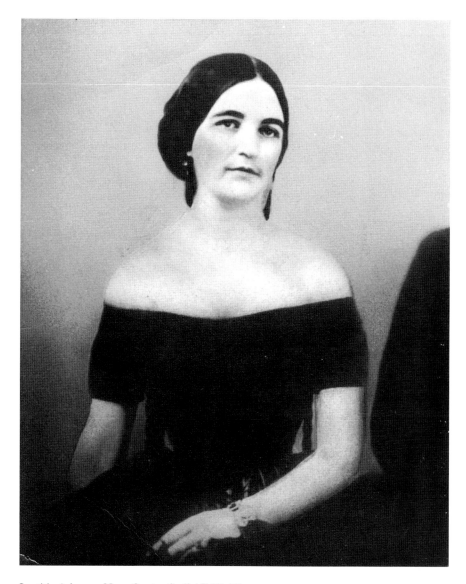

Laetitia Ashmore Nutt. *Courtesy Sanibel Public Library.*

her property for financial benefit. Her tax bill in 1897 was $4.66 for 109 acres on the Gulf.

In 1889, she built a large home, Gray Gables, which still stands on West Gulf Drive. They turned the house into a boarding school and charged three dollars per month per student. Her three daughters traveled by foot around the island to instruct the children of winter residents living along the beach.

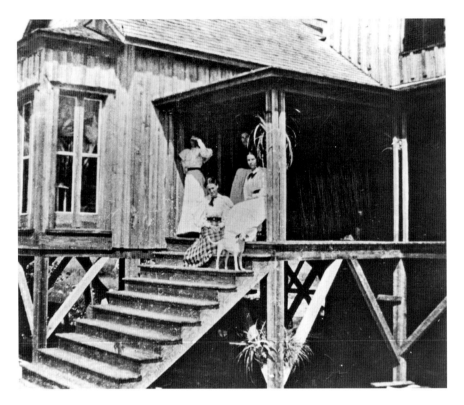

The three Nutt sisters on the porch of Gray Gables. *Courtesy Sanibel Public Library.*

Laetitia's two eldest, Cordie and Lettie, fell in love but never married since Laetitia didn't approve of their choices. Nannie married Nels Holt after her mother died in 1914.

Laetitia was the first postmaster on Sanibel and hiked from West Gulf Drive across the island to Matthews Wharf to pick up the mail. Tired of this arduous journey, she soon requested a replacement.

Cordie, Lettie and Nannie continued to teach after their mother's death. Miss Cordie, as she was known to her students, helped organize Jones-Walker Hospital for Negroes in Fort Myers, as well as Lee Memorial Hospital. She was involved with the Sanibel Civic Club, now the Sanibel Community Association, and donated the land to build the Sanibel Community House.

Lettie, quick and peppery, was an ardent conservationist all of her life. In 1915, the two elder sisters, Cordie and Lettie, moved into Palm Cottage, selling Gray Gables to an Episcopal sisterhood. A few years later, family members bought back the home. One of Laetitia's ancestors still owns it.

FLORA WOODRING MORRIS

Samuel and Anna Woodring homesteaded 160 acres on Tarpon Bay and built a large frame house on the land in 1888. A year later, they welcomed a daughter, Flora Sanibel. She was the first white child born on Sanibel.

In one of her last interviews, Flora remembered her childhood on Sanibel as a mixture of hard work and fun. She helped her mother run the first hotel on Sanibel by caring for the guests. When she had some free time, she'd roam the beaches and explore the interior of the island.

Flora often spoke about growing up on Sanibel, where going to school was a challenge. The only way around the island was on foot or by boat. The young girl traipsed through sawgrass and across sand flats to get to class.

When she was older, she sensed the wonder of her childhood, reminiscing about the famous archaeologist Frank Cushing's visit to their neighbor Sam Ellis on Tarpon Bay. Her father had even guided Cushing among the ancient shell mounds that still remained.

Flora fell in love with Fort Myers resident and future Lee County councilman John Morris. However, their marriage almost didn't take place. She recalled the near disaster during the 1910 hurricane. She and one of her brother's wives were home alone with her two nieces. Not bothered by the approaching storm, the two women didn't notice the gathering clouds or whitecaps forming on San Carlos Bay.

Suddenly, she noticed the rugs floating in the living room. By this time, the wind was violently slapping the shutters against the house. When she peered out the window, she saw that all the water had been sucked out of San Carlos Bay. For the next hour, she and her sister-in-law tried to evacuate to the newly built house next door, which was standing some feet above ground. Finally able to make the move, the foursome remained awake all night listening to the howling wind and rain.

The following morning, Flora's fiancé, John, came by boat looking for her. What he saw caused him great anguish. The water that had rushed back into the bay had destroyed the Woodring home. Flora, however, waved to him from the house next door. Many years later, Flora told her son, Robert, about the hurricane and warned him not to remain on the island when a great storm was predicted. After that experience, she was only too happy to leave the island and live with John in Fort Myers.

Flora, twenty years younger, married John Morris in 1911. They moved to a house on Monroe Street, where their son, Robert, was born. As a young boy, he often accompanied his mother to Sanibel, where the two would hike

to the lighthouse beach and search for sea grapes. "My mother made the best sea grape jelly. We put it on everything," he recalled in his last interview. Flora stayed on Monroe Street for fifteen years after her husband's death and remained active in her community and church until the 1970s, when Robert brought her to live with him in Georgia. Although she died there, she always considered Sanibel her home.

JANE MATTHEWS

Jane Matthews was a wealthy widow who fell in love with Sanibel the minute she laid eyes on the island. An ardent follower of the Reverend George Barnes, she took his advice and decided to change her life.

Looking for adventure, she left her home in Cincinnati in the early 1890s and homesteaded 160 acres of land along the Gulf beach, adjoining the Nutt parcel. She built houses for investment along with two piers, which she dedicated to the people of Sanibel in February 1896.

There was a deep-water inlet that abutted her property on the bayside. Islanders, realizing that boats from the mainland needed to be able to

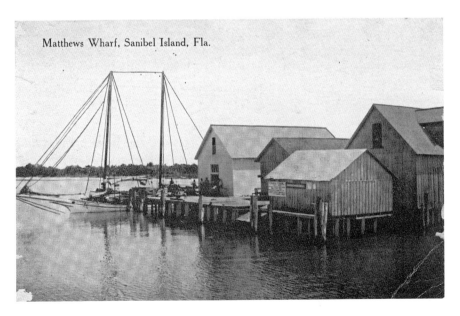

Matthews Wharf, Sanibel Island, Fla.

Jane Matthews's wharf before the 1926 hurricane. *Courtesy Sanibel Public Library.*

stop at the island to transport goods to the railroad for delivery up north, had petitioned the U.S. Coast Guard for many years to build a dock.

Exasperated by the long wait for a reply, Jane gave permission for the locals to build their dock. Knowing that it would be too difficult to remove, the government permitted it to remain. With a plantation store at the end, it became a busy shipping point and the center of island activity until the 1926 hurricane blew it away.

A second dock, with a bathhouse at its midpoint and a pavilion at its end, extended several hundred feet into the Gulf of Mexico, east of Jane's home. Frequently washed out and rebuilt, it was lost in the storms of the 1920s.

Jane died shortly after the turn of the century and left her homestead to a niece, along with a bequest of $500 to her friend Hallie Matthews. The niece and Hallie switched bequests, and Hallie built what is now the Island Inn. Had it not been for Jane taking the bull by the horns and building the dock on the bay, who knows if Sanibel would have been such a successful commercial market for tomatoes, citrus and other farm products?

Lucy Reed (Daniels)

Once upon a time, there was a boat named the Floating Palace that wasn't a palace and didn't float. It was a hotel, constructed on a lighter boat that anchored at Boca Grande. It was towed each spring through Captiva Pass and into San Carlos Bay, where it anchored. This is how moneyed winter visitors could live on the water and fish for tarpon. So it did float for brief periods each year.

It was operated by Lucy Reed Daniels. Lucy married John B. Daniels, and by the 1900s, they had two children, Bertha and Haskell. Lucy was the sister of Will Reed, postmaster, and daughter of Captain Reed, who homesteaded 160 acres along San Carlos Bay. In the autumn of 1907, she witnessed the death of her husband at the hands of a drunken worker on their farm. Though overwhelmed by this tragedy, she was able to prosper thanks to her inheritance. That year, the pepper crop on the farm was excellent, and with these earnings and additional financial help from her father, Lucy bought the Floating Palace, put it ashore permanently in 1908 and named it the Sanibel House. It became a popular small hotel.

This area was very important to the residents. Not only was it a place where people could get their mail, but the Bailey Store was also next door

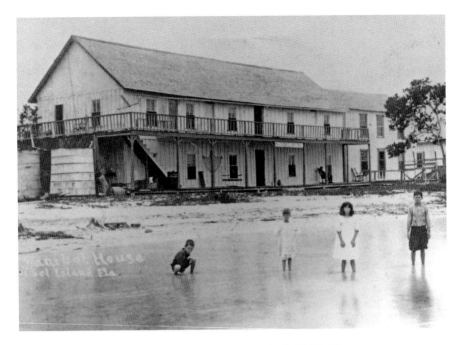

The Sanibel House at Reed's Landing, 1911. *Courtesy Sanibel Public Library.*

on Matthews Wharf, which was the dropping-off place for people and goods for the mail boats and steamships.

Lucy remarried in 1910. Her second husband, O.L. Richardson, built a subdivision in the interior of the island.

During the 1926 hurricane, her son, Haskell Daniels, and his wife were staying near Matthews Wharf on the bay in a house, later known as Miss Charlotta's Tearoom. During the eye of the storm, they attempted to go to the lighthouse by car to send a telegram to Frank Bailey notifying him that his store had been destroyed. The car was overwhelmed by storm waves, and the couple had to wade to safety. The wrecked car remained on the beach for years as a marker of the storm.

MARIE BARNES

Reverend George Barnes arrived on Sanibel in 1889 after an illustrious career as an evangelist. Because of his journeys into backwoods Kentucky, the *Louisville Courier* called him the Mountain Evangelist and printed one of

his sermons each day. After finishing at Princeton Theological Seminary, he married Jane Cowann, and the two were sent as Presbyterian ministers to India. While there, Jane gave birth to three children: Marie, William and Georgia. The family remained there for twenty years. After returning to the United States due to ill health, Barnes was tried for heresy and thrown out of the church because of his unorthodox opinions.

A friend suggested he become an evangelist, and the now acclaimed preacher took his crusade worldwide. Marie, devoted to her father, traveled the endless winding mountain roads of Kentucky, bringing her organ in a horse-drawn cart. As his eyesight began to fail, Marie read the scriptures for him.

In 1883, with Marie at his side, he made a successful world tour. Six years later, the family was in Punta Gorda when they went cruising with friends. When their sloop went aground in San Carlos Bay, the passengers waded onto shore and discovered the pristine beauty of Sanibel.

That same year, each member of the family laid claim to a 160-acre tract along the Gulf. Barnes believed God had brought him to the island. In 1890, they built a cottage-type hotel, which they named the Sisters because it lay at the junction of Georgia and Marie's land.

This hotel became a fashionable and popular resort known for its East Indian food and the hospitality of its owners. Georgia married Edward Duncan, and they built a home next to the hotel called the Thistle Lodge.

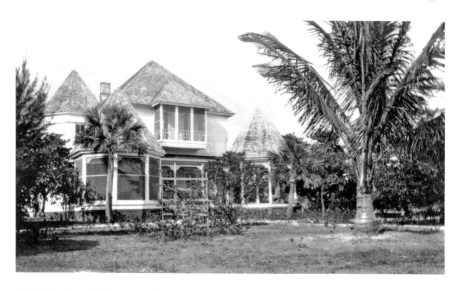

Thistle Lodge, 1924. *Courtesy Sanibel Public Library.*

Marie remained single. After the death of her parents, she became interested in the work of evangelist Aimee McPherson and, in the early 1920s, moved to California.

Chapter 3

The Women of Wulfert

With land sometimes scarce in certain areas, islanders would pick up and move to another place, farther down the island. They'd choose a patch, plow it up and farm it. It was theirs for the taking. Homesteaders were glad to let others work their land; thus, scrub and wild palms were removed.

Some settlers pushed on to a place known as Wulfert because of the access to bay and sound. During the 1890s and well into the 1920s, it was a busy farming community. The name originated with the post office, and the

Wulfert Point Dock, early 1900s. *Courtesy Sanibel Public Library.*

area was named after no one or nothing in particular. Mason Dwight settled here and put an ad in a Texas newspaper for a partner to help him clear the land and set up an orange grove. A man named Holloway answered the ad. Dwight farmed, and Holloway ran the store at the end of the wharf. While islanders bought necessities, Holloway made use of a unique disposal method. There was a convenient hole cut in the floor so customers could drop a half-eaten tomato or an orange peel into the water below, where it was whisked away by the tide.

Mary Dos Santos

Oliver Bowen, a Mississippi River riverboat captain, and his wife, Mary Dos Santos, were among the first to farm the area. They arrived in 1887 and laid claim to eighty acres. They had brought their ship from Port of Spain, Trinidad, with their two children. The sailing vessel was loaded with household items, building materials and farming equipment—they intended to stay. Oliver had also brought agave, hoping the sap would be a substitute for rubber. Mary often joked about Oliver's moneymaking abilities, stating that the only time he made anything was when he sold the skin of a snake he'd caught.

Mary ran the farm, growing vegetables for northern markets. Oliver's favorite pastime was sailing down the river to spend the afternoon with Thomas Edison or lying in his hammock by his well.

Mary had learned lacemaking as a child on Madeira, and when their youngest son, Albert, was born

Mary Dos Santos Bowen traveled to Sanibel from Trinidad in the early 1880s. *Courtesy Sanibel Public Library.*

36

in 1890, she made him an exquisite pair of lace stockings. Albert remembers wonderful times spent on Sanibel when the children would swim in the bayou, go fishing and play with the carved wooden animals Oliver made.

Oliver asked Mary to bury him in the well when he died. In 1894, Mary honored his request. A workman filled in the well almost to the top, then enlarged it to fit the coffin. After the funeral, he put a concrete slab over the grave and then placed a tombstone. When Mary completed her homestead, she took Albert back to Trinidad. Sometime after that, she returned to California, where she died in 1922 in Los Angeles.

JEANNE DOANE

In 1883, Lewis Doane married Jeanne, a woman eight years his junior. Their only child died in infancy. Jeanne was a staunch believer in women's rights and showed this attitude in her dress. She posed for a wedding photo in a dark, tailored, calf-length dress over matching long pants. On other occasions, she would wear a dress or skirt and bloomers that reached the tops of her high-buttoned shoes. The Doanes lived in Vineland, New Jersey, and Ocala, Florida, before homesteading on Sanibel in 1897.

Jeanne was the first postmaster at Wulfert, and it was said she never stopped being a northerner. She lived in a fairytale house for nearly fifty years and only once left Wulfert. That time, she boarded one of the little steamers and sailed up to the village of Fort Myers

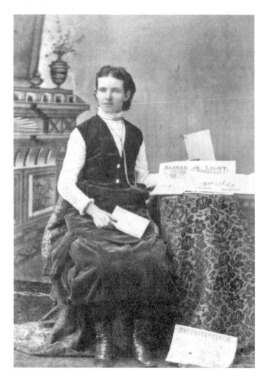

Jeanne Doane was the postmaster at Wulfert in the 1890s. *Courtesy Sanibel Public Library.*

to purchase some records for her new cylinder Edison phonograph. She wanted to hear the records before she bought them.

In the 1920s, after most of the old-timers were gone from Wulfert, Jeanne had a beautiful flower garden. Newcomers to Sanibel would go there to buy flowers and "borrow" cuttings to start their own island gardens. She also raised chickens. Neighbors believed that she had come to Wulfert to establish a spiritualistic colony. Though this colony never materialized, she continued her beliefs and would hold séances, during which tables moved and ghostly voices spoke. Well-liked, she and Lewis had some unusual ideas, one of which involved their burials: they built their own coffins and kept them in their house until needed.

Pearl Stokes

In 1898, W.L. Hunter homesteaded in Wulfert and married Linnie Gibson, and in 1909, their daughter, Pearl, was born. Pearl, who lived to be over ninety, recalls life at Wulfert before the 1926 hurricane. Her grandfather Amanta Gibson came to work for Holloway and Dwight on their homesteads in 1900. Later, the family struck out on their own. They had hard times farming cabbages. Once the hot sun "burned up" the cabbages, and another time, Amanta found the patch in ruins. During a dry spell, raccoons dug into every head looking for water. The worst time was when the wind came from offshore—the mosquitoes were terrible.

At such times, those living in palm-thatched huts used smudge pots filled with buttonwood to drive the pests away. A few settlers even had cheesecloth coverings at their window openings and kept a heavy smudge pot by their doors to keep out the bugs.

Pearl heard tales from her father about the early days. Arthur Gibson, at age twelve, learned to fish with a cast net. Other food sources for the pioneers were rabbits and gophers. Shellfish and turtles, oysters and clams were abundant. They could also sink a barrel in the sand and dip up drinking water almost anywhere on the island.

Pearl knew Mary Dos Santos. Her father, Arthur, was shocked to find Oliver's grave empty one morning. Apparently, after Oliver died and was buried in his well, his eldest sons came back and asked Arthur to show them the burial spot. Under the cover of darkness, the men snuck back the next night and removed their father's body. When Arthur went to the wharf in

search of them, their sloop had gone. Years later, when Arthur was living with Pearl and her husband, the sons came back to "make amends" for robbing their father's grave and brought them bushels of fruit. Pearl thought that was very strange.

Pearl and her husband remained on the land, and her great-great-grandson Marty Stokes still lives in Dinkins' Bayou.

Chapter 4

Life Before the Depression

Islanders, for a time, were living the good life. With the advent of the railroad to Fort Myers and the lighthouse beam making shipping safe, farmers were able to transport their crops north. William Binder sold off his land to wealthy tourists from the North who enjoyed the abundance of fish around the two islands.

Even after the hurricane of 1910, farming on the islands was still prosperous. As the population grew, newcomers considered building more homes on Captiva.

After World War I, that changed forever. Farmers, still able to grow their crops, could send them to northern markets, but many of the first arrivals left the island for Fort Myers or Florida's east coast. The younger generation didn't want the isolation or the responsibilities of a farm. Tourism became one of the mainstays. It was still cold up north, and the warm breezes and pristine beaches covered with shells were a big attraction.

The hurricanes of 1921 and 1926 ended commercial farming, and islanders had to adjust.

Farm packinghouses quickly turned into boarding hotels for tourists. Women took a more prevalent role and became restaurateurs and hotelkeepers while men continued to work the land and fish the waters. Farmers needed workers, so a group of residents went to the Dunbar community in Fort Myers and offered jobs to men living in the black community. Isaiah Gavin, one of the first sharecroppers on Sanibel, was happy to work for a dollar a day.

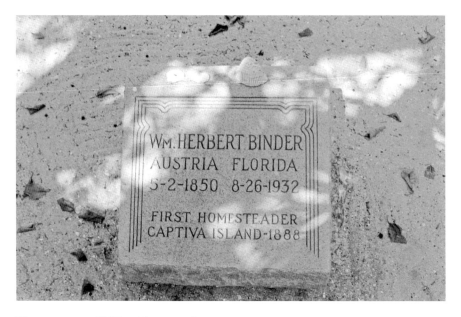

The gravestone of William Binder, the first homesteader on Captiva. *Photo by Manfred Strobel.*

On account of the segregation laws that permitted separate schools for blacks and whites, laborers worked on the island for the week and then returned to Fort Myers on the weekend to be with their families. Tired of this arrangement, Edmond Gavin asked the owners of an abandoned church building to allow the black community to use it as a school. Before long, all the workers' families had moved to the island and become an integral part of the community.

JULIA DICKEY

In the winter of 1906, John Dickey, a pharmacist from the North and an avid fisherman, brought his wife, Julia, and their three sons to Sanibel on vacation. Dickey was not pleased with the distance from the bay to the beach on Sanibel for fishing and went exploring on Captiva, the narrower island. Julia loved to shell and wanted to be closer to the beach. Dickey ended up buying a large piece of Gulf-front property from William Binder on a handshake. The couple returned the following year and built a number of houses for their extended family.

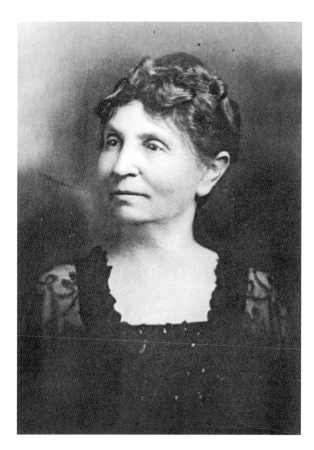

Left: Julia Dickey was a concert pianist who was taught by Franz Liszt. *Courtesy Sanibel Historical Museum and Village.*

Below: Captiva Drive in the early 1900s. *Courtesy Sanibel Public Library.*

Julia was a concert pianist who had been trained in Europe and played for Franz Liszt. She didn't have much in common with the farmers on Sanibel and Captiva and invited northern friends to visit and stay for the winter. If they liked the island and pledged to return each year, she would give them a piece of land to build a house.

Julia quickly adapted to the islands. She kept chickens, which ended up gracing her Sunday dinner table for family and friends. However, she became concerned when a raccoon began to raid her chicken coop at night. At her wits' end, she shot the raccoon and baked him for dinner. After that, she decided that the raccoon was more than welcome, it being a delicious respite from all the chicken.

One Christmas, Julia decided to plant an orange grove. She was noted for her green thumb and did everything right, but the grove failed. Always on the lookout for an alternative, she visited other islands and found coconuts on Buck Key. She also brought hibiscus bushes from friends on Sanibel. One of her favorite finds were the Australian pines on Boca Grande.

On the advice of postmistress Hattie Brainard, Julia established the first Captiva Sunday school by opening the Dickey house to all island children.

HATTIE AND ANN BRAINARD

In 1896, Herbert Brainard, a dairy farmer from Canada, arrived on Buck Kay with his wife, Hattie, and their two children, Ann and Gordon. Before leaving, both children had been given a gold piece by their grandparents. The Brainards planted citrus groves, and during the next five years, Hattie gave birth to four babies who died in infancy. Ann and Hattie would frequently row across to Captiva and watch the sunset from a special spot on the beach. Ann became enamored of the land and took her gold piece and offered it to William Binder if he'd sell the property. Hattie and Herbert's greatest tragedy occurred when Ann stepped on a nail and died of tetanus in 1901. Ann is buried in her special spot, now the Captiva Cemetery, where she can watch the sunset.

Hattie became the island midwife and was appointed Captiva's postmistress in 1903. She served in that position for thirty-five years. Her post office was a box-like enclosure in her own home, which was no more than a thatched hut. Herbert continued to farm but met a tragic death. Several black field hands worked on his farm, but one day, Brainard and a

Captiva Library's interactive display of the Santiva mail boat. *Photo by author.*

Alvin and Hattie Gore (back right) in the early 1900s. *Courtesy Captiva Island Historical Society.*

hired man got in an argument. It ended with the hired man striking Brainard with a grub hoe. In three days, Brainard was dead, and for years afterward, no black workers were allowed on the island.

After Herbert died, Hattie developed an interest in spiritualism and started corresponding with Alvin Gore from Kansas. They were married in 1915 and quickly converted Hattie's home and post office into the Gore Hotel, a local landmark and place for arriving residents and tourists to take refuge. Hattie was said to provide delicious meals, serving bacon, fried chicken, fish loaf bread, biscuits, rice and garden vegetables. She made her own yeast out of cornmeal and cut it into squares that were dried and hung in bags. She used potato water and made excellent potato bread.

Hattie died in 1945 at eighty-two and is buried with her children in the Captiva Cemetery. The Gore Hotel was blown apart in 1960 during Hurricane Donna and burned down shortly after.

Louise Riddle

Louise's father, George, was a farmer who bought eighty acres of land on Casa Ybel Road. His farm was so successful that he ran a store on Tarpon Bay. Louise remembers packing tomatoes for shipment to New York: "We used to wrap each one in tissue before we shipped them." Louise enjoyed milking the family's two cows and churning the butter. She was in charge of the food stored in a large pit under the kitchen floor. It was filled with sawdust and served as a receptacle for a large piece of ice brought each week from the dock at Matthews Wharf.

Louise loved to go to the beach every day with her mother and search for shells in front of the Casa Ybel Resort. She remembers being overwhelmed with mosquitoes when the sea grapes became ripe. Louise's mother armed each child with a smudge pot as they picked grapes for her jelly.

During the hurricane of 1910, the entire island went underwater, and many houses were blown off their foundations. The Riddles took refuge in their packinghouse, stowing the children in the vegetable bins. The aftermath of the storm produced a layer of salt that burned all the vegetables. The Riddles tried to farm for four more years before hiring Captain George Cooper's passenger freighter to transport the family, household goods and livestock upriver to Fort Myers.

Hallie and Charlotta Matthews

In 1895, Will and Hallie Matthews traveled to Sanibel. They were followers of Reverend George Barnes and were mesmerized by his stories of the beauty of the island. They rented a cottage owned by Jane Matthews (no relation). They brought their four children: Annie Meade, Douglas, Charlotta and Clark. Hallie was a wonderful cook, and Jane asked to take meals with her. By the end of the season, so many people were asking to eat at Hallie's that Jane suggested they pay her. Before long, the first home restaurant was born.

When Jane died, she left Hallie $500 and her land to her niece. Since the niece didn't want to live on the island, she asked Hallie to switch inheritances.

Will had tried his hand at farming, but he and Hallie were far better innkeepers. They built a number of cottages and enjoyed such a fine reputation that in 1917, they built the Barracks, the most impressive place on the island.

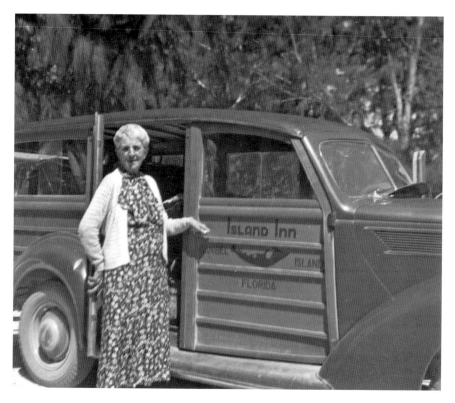

Hallie Matthews standing by her station wagon for the Island Inn. *Courtesy Sanibel Public Library.*

Right: Charlotta Matthews in the 1950s. *Courtesy Sanibel Public Library.*

Below: Miss Charlotta's Tearoom at the Sanibel Historical Museum and Village. *Photo by Manfred Strobel.*

A dock built in front washed away twice. When Will died in 1927, their daughter Charlotta returned to the island to help her mother run the hotel, which, in 1937, was renamed the Island Inn. It remained in the family until 1957, when it was sold to the Island Inn Company, a group composed of winter residents who had been visiting the hotel for years.

Hallie was a bundle of energy with a quick wit. When indoor plumbing was still a vision of the future, she had hot water brought to each room in the morning and evening. A prospective guest once asked Hallie where the bathtub was, and with a regal sweep of her head, she indicated the Gulf of Mexico.

Charlotta Matthews, a spinster, was very set in her ways when she came back to help her mother. When her sister, Annie Meade Bailey, died in 1935, leaving three young boys, Charlotta moved into their home. She also didn't like to be called "Aunt," so her nephews nicknamed her "Chebum."

Charlotta found living with and trying to discipline her sister's boys too much. She moved out and went back to work at the hotel. In the early 1930s, she used her experience running a dining establishment to start "Charlotta's Tearoom" next to the Bailey's store. The restaurant's building was sturdy enough to survive the 1926 hurricane. All the food served at the tearoom was cooked at the Island Inn and transported to the wharf area. People waiting for the ferry would congregate at the tearoom for sandwiches, lemonade and gossip. Miss Charlotta knew everybody's business on the island.

PEARL ALICE WALKER

Pearl Alice and her husband, Harry, came to Sanibel in 1926 from Freedom Grove, Georgia, with seven children to sharecrop for the Bailey Packing Company. They were the second black family of sharecroppers on Sanibel and raised all their children on the island.

Pearl is remembered by her grandson Eugene Gavin as a strict disciplinarian. "But she did it with love," he noted. She always encouraged her grandchildren to become the best. Pearl worked as a domestic while raising her children and caring for their farm. "She always asked me to do anything that required mechanical or engineering skills," said Eugene. "One day she asked me to dig a well. I grabbed a shovel and brought that well to life."

Racism was not a big issue on Sanibel, but on one occasion, it was suspect. One day in the late 1940s, the Walkers returned from the mainland

to find that someone had set fire to their home. With the help of their brother-in-law, Isaiah Gavin, the Walkers relocated to a home on Tarpon Bay, where Pearl remained until her death in 1987. Her kind spirit and loving attitude made her a beloved member of the community.

ELNORA WALKER GAVIN

Elnora was born to Harry and Pearl Walker in 1921 in McIntosh, Georgia, and moved to Sanibel in 1926 with her six siblings. She was one of the first black women to be married on the island and raise a family. She and Edmond had grown up together and decided to get married when they were in their teens. This idea did not sit well with Elnora's mother, Pearl Alice, who was very strict. Elnora talks about that time in an early interview: "Edmond had a hard time getting her to let him take me somewhere. She told him that I was too young to get married. He told her that he knew how to cook and for a while that didn't set with her."

But as soon as the union was officially blessed, Pearl changed her tune. Then she told Elnora to be nice to Edmond and have his meals ready. Elnora ultimately raised eighteen children, many of whom still live on the island and own businesses. According to her granddaughter LaVonna Davis, Elnora had a tough time remembering all their names, so when one of them needed to be reprimanded, she'd refer to them as "boy" or "girl."

In 1985, Elnora and Edmond celebrated their fiftieth wedding anniversary. It was a great occasion when all their children returned to the island. Elnora's son Eugene remembers her fondly: "She provided us with the main ingredients for life and taught us respect, kindness and how to love one another. She loved kids and people in general. Her whole life centered on family." She died in 1991 at the age of sixty-nine.

Chapter 5

Tough Enough to Survive

The ravages of the Great Depression were less pronounced on the islands than on the mainland of Florida. Doom and gloom had settled on most business establishments after the crash of 1929. People were not jumping out of windows, but there was a decrease in visitors. Bank failures must have impacted everyone, but trade still went on with farming, fishing and other services. It was possible to have the necessities. In addition, neighbor helped neighbor.

One of the brighter lights during this time was President Roosevelt's WPA (Works Progress Administration). This organization was good for the island—it paved the main roads on both Sanibel and Captiva. It was nice for residents and visitors not to have to travel over those muddy ruts or sand-and-shell bumpy roads.

At the same time, somebody with a map discovered that Sanibel, sitting east and west instead of north and south in the Gulf, lay open to currents from the Yucatán and the Caribbean. That was the reason for such beautiful shells cast ashore. Besides the Australian Barrier Reef and the Pacific Islands, Sanibel was considered the finest shelling beach in the world.

Thus the "Sanibel Stoop"—a position or posture characterized by perpetual leaning over and the unmistakable position of the seashell collector—became the fashionable stance. It was a hobby born of the Depression years, one that you could pursue at your own pace and on your own time, alone or with others.

Folks left their cars at Punta Rassa and rode the ferry to walk across Point Ybel and shell all day. A shell beach was the great leveler. One might meet

Edna St. Vincent Millay seeking inspiration from a lacy murex or Mrs. R.V. Perry, physician and zoologist from Asheville, North Carolina, adding to her collection and planning a poem of her own about the seashore.

On Sanibel and Captiva, news reports of the day weren't required to be earth shattering, just pleasant and folksy and containing enough familiar names to make them palatable. Stories of night trips for bootlegging and for secret plundering of Indian mounds appealed to the younger set. Amateur theatrics became the craze during the Depression years. The islands offered the joy of escape and calm to carry through for better days.

DESSA ROSSE

After the devastating hurricane of 1910 and the loss of acres of farmland, northerners saw opportunities on Captiva. A Connecticut Yankee, Captain F.A. Lane, bought a piece of land stretching from the bay to the Gulf and named it Palm Avenue. A few years later, he constructed a hotel and a small cottage for his wife. To help sell the property, he dredged and filled in all the lowland along the bay to a standing dock formerly owned by the early settlers. A small fish house and store were added to help promote settlers to buy in the area. Pop Randall owned the store and ran it until he died. All the local fishermen used the dock for business and pleasure.

Andy Rosse, who was born in England in 1903 and traveled to Tampa with his family, moved to Captiva at sixteen and became an avid fisherman. He met his fourteen-year-old future wife, Dessa, in Punta Gorda while swimming off an old city pier.

With the approval of her parents, they traveled by boat to Fort Myers and got married in 1924. At first, they lived in St. James City on Pine Island and moved around just fishing. Dessa didn't like fishing, so Andy bought a truck and hauled junk, which earned good money. When Andy got tired of that, he went back to fishing.

He and Dessa were able to make twelve cents a pound for trout and caught four to five hundred a day. Dessa didn't like being out all day and would pester her husband to go home. He told a story about how he had a "big one" hooked and was reeling it in when she yelled at him, "Can we go home NOW?" Disgusted, he threw the pole and fish overboard and shouted back, "Yeah, you're damned right we're going home, and you a'nt never going fishing with me again!"

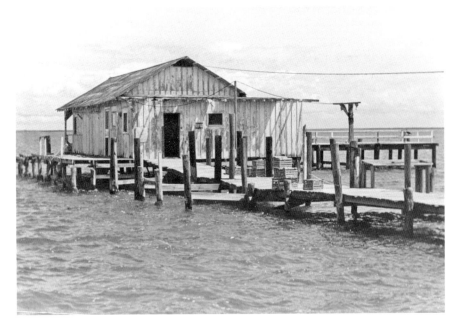

Andy Rosse's dock. *Courtesy Sanibel Public Library.*

In 1926, they settled on Captiva to care for a fish camp with a big icehouse. Andy went fishing during the day while Dessa ran the camp, but she was bored. To entertain her, Andy bought his first guitar, and she ordered a ukulele from Sears, Roebuck. Still bored, Dessa took a job on Captiva, and Andy returned to fishing.

After their first child was born, they decided to put down roots and build a house on Captiva. Hattie Gore gave Andy permission to live on a piece of her property about two blocks north of the Green Flash until he could buy something of his own. He built the house of palmetto cabbage palm fronds, and the floor was made from seashells. They called it "the shack." Andy made all the furniture out of boards he found on the island. Dessa cooked on a kerosene stove and pumped water from a well they dug next to the privy.

In 1935, Andy started commercial fishing at 'Tween Waters, where he made fifteen dollars a day. He also was provided lunch. Since it wasn't always enough money, sometimes when Dessa picked him up after work, he'd have saved half his sandwich for the children. A few years later, Andy borrowed money from Jay Darling to buy Pop Randal's Dock.

The first thing he did was build a restaurant. It was a noisy place with the jukebox blaring, but the locals loved it. Wild things were always

happening at their dock. Sometimes there was a knife fight between the fishermen, but it was always in fun.

One time, Dessa got so mad at what was happening in the bar that she threw the cash register into the water. When she wore out a pair of shorts, she'd also toss them into the water. Things were very laid-back in the establishment. She would only cook a hamburger for a customer if she felt like it.

According to islander Dr. Hofschncider, Dessa loved to do things that irritated Andy: "Every morning, she would go to the dock, take off her shoes and leave them outside the bar. Then she'd mop the bar floor. Andy didn't like her doing that kind of work. He'd pick up her shoes and toss them into the water. And every time he'd do that, she'd be waiting for the mail boat the next morning to order new shoes."

Her constant outfit was a halter top and bloomer pants. She had no trouble handling the rowdy customers and even threw a member of the health department out the door when he complained about her dress.

Dessa was cherished by Andy and well loved by all the islanders. When Andy wasn't around the bar, the local customers would protect her from advances by any strangers.

Andy's dock attracted all kinds of people: the Lindberghs, Adlai Stevenson and wealthy entrepreneur Alice O'Brien. She had heard from her maids about the great parties at Andy's dock. She asked Andy to reserve a day for one of her events. A few days later, Dessa asked how many she was having, and Alice replied about eighty. When Andy heard that, he told his wife the dock would collapse. Alice adjusted the guests to fifty, but Dessa spent the night worrying about the dock disappearing into the water.

Dessa died in 1966, and Andy never remarried. He told his friends, "Dessa was one of a kind."

MILBREY JENKINS RUSHWORTH

Milbrey arrived on the island in 1902 with her grandparents Bailey and Edythe Buck and stayed at the Matthews Hotel. Eventually, her grandparents bought a cottage next to the Island Inn. In 1933, at the age of seven, she and her sister, Ede, and her parents, Bill and Christine Jenkins, came to the island for the season. She remembers a pageant at the Sanibel Community Church for which her sister was supposed to be an angel but ruined the affair by having a temper tantrum on the altar.

During the Depression years, it was cheaper to live on Sanibel than in Michigan, so her family came for six months in 1933–34 and ate a lot of macaroni and cheese.

Her earliest memories were of the wonderful Christmas when her father made doll houses out of orange crates. The Jenkins tree was decorated with shells and oranges stuffed with cloves, and the girls used their mother's nylon stockings to hang on the mantelpiece. On one occasion, her father mixed a tub of grapefruit wine, but it blew up before they could drink it.

The Depression era didn't stop residents from having rum parties on the beach. Webb Shanahan, the postman, would take orders from residents via the mailbox.

Milbrey's parents moved to the island permanently in 1949, and in 1954, Milbrey met her husband, Jack. He had been hired as assistant manager of Casa Ybel. After the couple married, they left for Jack's job in Tobago. A year or so later, she and Jack came back to the States because she was pregnant. They lived at her parents' beach house and became managers of the Island Inn, where they remained until retiring in 1990.

Milbrey spoke often about surviving the mosquitoes: "We never went outside to hang wash unless we covered up from head to foot. And we always kept a spider at the end of the hall upstairs for mosquito control."

At this time it was difficult to find a teacher for the school. The children were wild, and the teachers hated living on Sanibel with all the mosquitoes. Milbrey was hired as a helper to teach the first three grades. She went to Fort Myers and had a couple hours of training. Then the teacher quit, and she took over. Fortunately, they found a real teacher, and she wasn't there too long.

After she retired in 1990, she became interested in undertaking the displays at the Sanibel Historical Museum and Village with her friend Mary Bell. At Christmastime, she was very specific about the decorations on the tree in the Rutland House, the first pioneer house brought to the village, wishing them to look authentic like when she was a child when the trees were decorated with shells and oranges stuffed with cloves.

In 2004, she chaired the antique toy and holiday display at the museum, which featured the island during the "not so depressing days." She continued being one of the historical authorities at the village until shortly before her death.

DAISY MAYER

Daisy Mayer; her husband, J. Ross; four of her children; and a maid named Elsie first came to Sanibel in 1919. Seeking warmer weather than the chilling cold of Erie, Pennsylvania, they first tried Miami, but it wasn't their kind of place. A business friend of Ross's had told him about Sanibel, and they decided to give it a try. The family arrived for Christmas after taking a train to Punta Gorda and a steamer to Bailey's dock on Sanibel. They stayed at Sawyer's Cottage. It was love at first sight for all of them. The following winters usually found them on Sanibel. Most of the time, they came by touring car, surviving a seven-day trip over terrible roads with all kinds of luggage, the now five children huddled under blankets anxiously searching for the next gas station.

In 1924, the Mayer brothers, Ross and Martin, decided to build houses on bayfront property they'd bought.

Ross and Daisy ordered the Verona, a Dutch Colonial design, which was one of the Sears, Roebuck prefab kits. It cost $4,200 and came in more than forty thousand pieces. The home had a garage, servants' quarters,

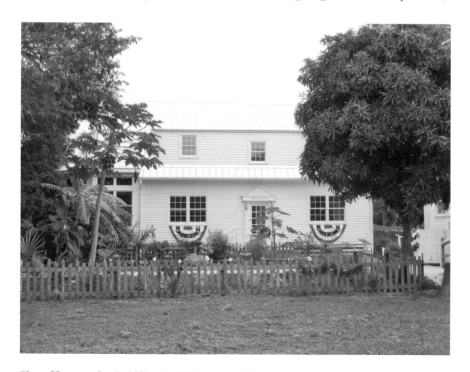

Shore Haven at Sanibel Historical Museum and Village. *Photo by author.*

rainwater cistern and an outdoor laundry. Ross hired Isaiah Gavin and his sons to clear the narrow ridge and underbrush. They worked together with shovel and wheelbarrow to fill the low, swampy places behind it with shell from the beach.

Eventually both homes—Shore Haven and Morning Glories, the home Ross's brother, Martin, built—would share a generator, an artesian well, a long dock and a bathhouse. And of course, most of the furniture was from Sears.

Anxiously, the family awaited the arrival of their home from Michigan. Ross had the house precut and transported by train from Michigan to Punta Gorda. From there, it would be carried by barge to Bailey's old dock and brought to the spot by Model Ts.

However, on the stormy day the barge arrived, some of the bundles of wood slid into the water. Daisy immediately gathered her children and asked them to retrieve the wood. They were told to pile up the pieces on the beach according to their proper number and letters—1a, 1b, 1c, etc. They didn't salvage everything, just enough to put the house together right. Daisy always claimed that the house "wasn't right."

Daisy added an upstairs porch and a breakfast nook. They put double screens on the house, but it didn't help keeping out the mosquitoes.

The second house was built (Morning Glories, a Springwood model, costing a modest $2,211), and the Mayer families used these homes as winter residences, enrolling the younger children in the Sanibel School. These were years of troubles as well as adventures. The hurricane of 1926 left their new home unscathed. Then, in the early 1930s, the Mayer's Pennsylvania construction business failed as the country went into the Depression.

Ross Mayer passed away, leaving his widow with debts and two young children. Refusing to sell either house, she managed to carry on and support her children. In the late '30s, Daisy sold the Erie house and came to Sanibel. She was terribly upset to find the house in such disrepair. With a combination of resourcefulness and guile, she went about the house "fixing things" with a butcher knife and screwdriver, often in front of the workmen who would, in horror, take her tools from her hands and fix it themselves.

Daisy had a good head for business, and even though there was not much in the family "coffers," she managed. Sometime during World War II, she made Sanibel her legal residence. Since gasoline was at a premium, it was easier to live on the island and not have to travel.

Daisy worked for the Sanibel Community Church, organized an Audubon chapter and served on several committees for the Sanibel

Community Association and shell fairs. Her life was full with friends, entertaining and long, thoughtful hours of fishing from her dock.

She was completely content, but as the grandchildren came along, she'd travel to faraway places to help out and rock all sixteen to the same old lullaby. Her daughters, Elinore and Gay, relate some family stories. Since Daisy liked to entertain, the house was the site of many parties. She had to be careful about serving liquor, because their neighbor was against alcohol of any kind.

Gay remembers trying to row across the bay to Punta Rassa but never quite making it all the way. Then she'd try to sneak up the stairs, only to be confronted by her mother and told abruptly to "go to bed!" According to Gay, "People like to call my mother sweet. That's not the word for it. She was too much of an individual with strong opinions."

Isaiah and Hannah Gavin were caretakers for the Mayers and, for a while, stayed in the two-room guesthouse.

Daisy remained in the house until 1969, when she died at the age of eighty-nine.

Chapter 6

A Place of Refuge

Sanibel and Captiva Islands proved to be a refuge for those seeking an escape from their everyday lives. During the Depression, the islands were held in suspension. An unknown poet of that time wrote: "On these lone isles the tumult of the town is all forgot."

In the early 1920s, Henry and Irene Shanahan built the Palms Hotel, a wooden two-story structure, on the beach at the east end of Sanibel. At this time, the Kinzie Brothers Steamship Line was running wood-burning steamers carrying mail and passengers from Fort Myers to Matthews Wharf. Arriving passengers had to be transported from the dock to the hotel. Because passenger service was in demand, the Kinzie brothers decided to provide ferry service also. They obtained a lease from the Lighthouse Board for use of a thirty-foot-wide strip of land across Point Ybel. On the bay side, they erected a small boat dock and a boathouse and laid a road across the point of land to the Gulf. Though tourists could ride from upriver to the island and walk across to the shore and gather shells, that wasn't enough. They wanted to bring their cars. In days past, islanders had their cars dismantled and fetched across the bay via steamer and then had them reassembled on the island. The Kinzies toyed with the idea of a car ferry, but they were not alone in their thinking. The following notice appeared in the *Fort Myers Press* in April 1925.

While the ferry service is being considered, the Fort Myers, Sanibel, Captiva Transportation Company will inaugurate a bus service…for the purpose of

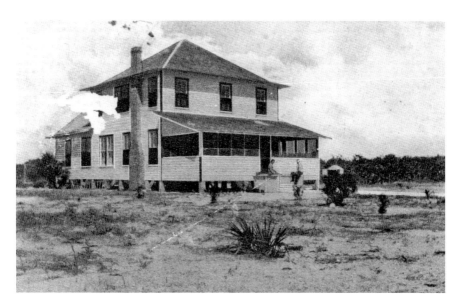

The Palms Hotel is where poet Edna St. Vincent Millay lost her manuscript during a fire in 1936. *Courtesy Sanibel Public Library.*

accommodating those desirous of visiting Sanibel Island before the ferry and ferry slips are put out of service. Speed boats will meet buses at Punta Rassa and take passengers for Sanibel. Automobiles will be available for trips through the islands.

It turns out that a man from Pensacola was behind this proposed ferry service that was supposed to operate to and from Reed's dock near the old post office on the bay. It never came to fruition, probably because of the 1926 hurricane. Once the Kinzies bought the ferry *Best* and hired Leon Crumpler as captain, there were no other competitors. Folks could now come to the island and enjoy shelling or vacation away their troubles. The sheer joy of escape and make believe on the islands triumphed over uncertainties.

LILLIAS COCKERILL

When Captain R.C. and Lillias Cockerill arrived on Sanibel in 1926, they brought a sense of adventure and fun. The slender, gray-haired Captain Cockerill was the author of *Songs of the Gods*. He not only spoke five languages

Lillias Cockerill. *Courtesy Sanibel Public Library.*

but also composed music. His wife, Lillias, who had a wonderful sense of humor, had been on the stage in England. In *The Unknown Story of World Famous Sanibel & Captiva* by Florence Fritz, Lillias tells this story about her very cultured husband:

When they trekked south from Canada to Florida, the locals thought he was from a foreign country since his speech was educated and precise. The owner at a gas station where the couple stopped to fill up their tank was speechless when he was asked this question by [her] husband: "Will you please ascertain if the differential needs lubricating?" Chuckling, Lillias translated: "He means, see if the rear end needs any oil."

Once on the island, the captain busied himself writing plays, songs and musicales to be performed and enjoyed by young and old. Lillias and the islanders acted in them, and all had a glorious time. When there were still oil lamps at the Sanibel Community House, Lillias and Ernest Bailey raised money for electricity in the building by putting on sketches that delighted everyone.

Two of these plays were *The Scarecrow and the Lady* and *The Little Shell Lady and Her Neptune's Guard of Honor.* Lillias also starred in Shakespearean plays with Frank Bailey. When not working on her acting, Lillias ran a boardinghouse.

Captain Cockerill died on October 25, 1948. After he was cremated, there was a problem with the disposal of the ashes of this renowned military man and playwright. Lillias knew he loved the sea and belonged there. After contacting the American Legion Post upriver in Fort Myers for approval, the Kinzies, who ran the ferry, agreed to take charge of the funeral and let the captain have a burial at sea.

While living on the island, in addition to writing, painting and acting in island plays with her husband and islanders, Lillias had become such a renowned conchologist that she received a letter from a fan in the Far East addressed to "Lillias Cockerill, Sanibel Island (wherever that is)."

She had requested that her ashes be spread on San Carlos Bay to join those of her husband when she died. After her death in 1956, Captain Leon Crumpler and the Kinzie brothers were obliging as usual. Her daughter and many old friends were aboard. They all sailed out into San Carlos Bay in view of the open Gulf. Four porpoises swam and rolled in the wake of the boat.

To scatter the ashes, the ferry needed to be in a certain position, or the wind would toss them over those on board instead of on the surrounding waters. That afternoon, the wind blew the wrong way, so Captain Leon sailed down the bay to a position opposite old Point Ybel. Then he turned and sailed back into San Carlos Bay. It was nearing sunset. As the ferry turned, so did the porpoises. Instead of trailing the ferry, they swam in pairs in front of it. Those aboard were in awe at the calm of the windless day. The

ferry paused, and the flag was dipped to half-mast. Leroy Friday, a friend, read Lillias's favorite poem:

> *Sunset and evening star*
> *And one clear call for me*
> *And may there be no moaning from the bar*
> *when I put out to sea*

The ashes of the gay and lively Lillias were scattered over the waters of San Carlos Bay to join those of her beloved husband.

DR. LOUISE PERRY

Dr. Perry and her husband first came to Sanibel in 1918 and found the island so lacking in conveniences that they turned around to leave on the next steamer. But another would not be on the island until the next day. The Perrys survived the night and decided to stay. In 1924, they built a home named Spindrift near Casa Ybel Resort, where two years later, Dr. Perry started a marine lab.

Louise studied malacology as a hobby and established her reputation in that field with her book *Marine Shells of the Southwest Coast of Florida* in 1940. A resident since 1926, she was noted for her generosity to the black community and her willingness to tend the injured and ill in any medical emergency.

She dredged specimens, raised junonias in aquariums, named fifteen shells new to science in two years and wrote reports on her findings. She also imported alligators from the Everglades when Sanibel's seemed to be nearly wiped out by hunting.

When neighbors needed medical attention, she provided it. A visitor trying to pay the doctor was informed, "We are glad to help each other on Sanibel for nothing." During World War II, she ran a children's eye clinic, examining 1,346 children without charge.

Louise is remembered as an enthusiastic door-to-door saleswoman for the eventual Lee County Electric Cooperative.

In 1939, she teamed up with Jay Darling to form the Inter-Island Conservation Commission that enforced state and federal game laws. In 1963, she donated 3.31 acres of Gulf-front land as a wildlife refuge. These properties formed the nucleus of the J.N. "Ding" Darling National Wildlife Preserve.

The Sanibel Community House in the 1930s. Shell Fairs were held there each year, except during World War II. *Courtesy Sanibel Public Library.*

She was responsible for keeping the Shell Fair going during the Depression, but during the war, the fair was postponed for several years. By 1953, the fair was so popular that the Kinzies were running ferries every twenty minutes.

In 1958, Louise sold Gulf-front property to Lathrop and Helen Brown. The couple then brought a car ferry down from Mississippi, converted it to a paddleboat and made it their home. Now known as the Algiers, the project was not complete before Lathrop died. After her husband's death, Helen left the island. The boat remained empty until Helen died and the city took over the land.

Louise was eighty-three when she died in 1962. In 1988 her shell collection was returned to Sanibel to be included in the displays at the Shell Museum.

EDNA ST. VINCENT MILLAY

Edna St. Vincent Millay is best known as one of the most respected American poets of the twentieth century. She made popular the phrase, "My candle burns at both ends." Millay was famous for her riveting readings and feminist views. She penned *Renascence*, one of her most well-known poems, and the book *The Ballad of the Harp Weaver*, for which she won the Pulitzer Prize in 1923.

In the winter of 1936, she and her husband checked into the Shanahans Hotel at the eastern tip of Sanibel Island. This hotel, also known as the Palm Lodge, was an exotic place that attracted people in the arts. For years, the hotel was run by Pearly Shanahan, the wife of postal carrier Webb Shanahan. Webb was the son of lighthouse keeper Henry Shanahan.

Millay had a set of poems ready to edit. She thought this quiet place would be perfect for the rewrites. Like many who came to the island then, she couldn't wait to get to the beach and enjoy the shelling and the sunset. She dropped off her luggage and dashed down to the water.

She was on the beach when the hotel caught fire, apparently caused by a faulty oil heater. Some of the guests barely survived with their lives, tying sheets together to get out the second story.

She and her husband lost everything, including a cherished seventeenth-century copy of *Catullus*, which she counted as her only "emotional loss," though a handsome emerald ring and her manuscript were also consumed in the fire. Millay later wrote of the event, "Swathed in something which once had been a white linen suit, and wrapped in a rug in lieu of a coat…we were so painfully unpresentable that we slunk into hotels late at night with our arms over our faces, and sneaked out before daybreak." Later, she would rewrite *Conversation at Midnight*, the manuscript she had brought, and it was published in 1937. Millay died in 1950 on her farm in New York.

ANNE MORROW LINDBERGH

Anne Morrow Lindbergh, wife of the famed aviator Charles Lindbergh, used to escape to Florida's southwest coast. On Captiva, she was inspired to write the famous work *Gifts from the Sea*. The book compared her life to the various shells she found while walking the beautiful beaches.

In the late 1930s and early 1940s, Anne and Charles wintered on Florida's Gulf coast. Sharing a love of nature, they traveled to the little unheard-of Captiva Island—accessible then only by boat—to recharge. In 1940 and 1941, when Charles was swamped with publicity surrounding his wartime views, they also escaped by sailboat to the swamps and marshes of the Everglades.

In her later years, Anne came by herself or with family to Captiva's secluded shores. She never publicly revealed Captiva as the source of inspiration for the book, which was published in 1955 and has sold more than three million copies.

"Bird of Paradise" cottage on Captiva was one of the homes rented by the Lindberghs. *Photo by Manfred Strobel.*

After Charles's death in 1974, formerly close-lipped acquaintances revealed the famous couple's clandestine getaway spot. Islanders and visitors celebrate with shrine-like devotion the island where the couple came to play outdoors. Anne had a wonderful view of her time on Sanibel. She wrote about her experience: "Island living has been a lens through which to examine my own life in the north. I must keep my lens when I go back. Little by little one's holiday vision tends to fade. I must remember to see with island eyes. The shells will remind me; they must be my island eyes."

Her book details an enchanted week after her flight to Captiva, away from her domestic duties as the middle-aged mother of five children. With her reflecting on the shells that she collected that week, she tried to unravel the problems and conflicts in modern life. She offers inspiring answers.

Longtime residents sometimes call Anne Lindbergh the "George Washington of Captiva" because everyone seems to want to claim that her book was written when Anne rented their house. Islander Bill Shannon tells an interesting tale.

Shannon, a Captiva business owner and former cab operator whom the Lindberghs engaged as driver on their three visits, recalls a conversation he had with Anne: "Mrs. Lindbergh told me she was writing a book when I

drove her around during her visit in 1950." Carol Sellers, island librarian who once owned a home they rented, claimed that the last two chapters were written on the island. Bill Shannon remembers her distinct fear of crowds. When she visited the island, he always picked her up at the remote whistle-stop in Murdock, Florida.

In 2005, Anne's daughter Reese and her niece Margaret Morgan came to the Captiva Inn to celebrate the fiftieth anniversary of Anne's famous book. The idea was the brainchild of Margaret, who lived in Fort Myers Beach. She was able to contact Random House Publishers, and it agreed to print a fiftieth-anniversary edition. Margaret recalled those special times walking on Fort Myers Beach with her aunt and wanted to celebrate her aunt's life in a special way. Reese, who was ten years old when her mother wrote the book, talked about the experience: "I remember being annoyed that she went away. But she was very happy when she came back. I knew something had happened, and I think it set her free. That's the reason it appeals to so many people."

The book started as a personal diary but became her most public statement. Reese also recalled trips with her mother in later life. "We would take her to 'Ding Darling' and then drive perhaps to 'Tween Waters; she loved to watch the birds."

Anne Lindbergh died in 2001.

Chapter 7
The War Years

During World War II, the island became a training ground for the military. A wooden tower was built halfway up the island on the Gulf. It was about eight by twelve feet and had windows all around. Men reached it by climbing a ladder and entering through a trapdoor. At Casa Ybel, two cottages were renovated into quarters for the military on duty there. Stationary targets were set up on the beach for planes to shoot, and sentries were placed on the road behind Casa Ybel to warn the school bus and islanders during practice.

Once a plane of trainers flew very low where fishermen were working. One man yelled to the other, "That damn fool is going to hit us!" The plane flew so low it tore off the end of the boat. Airmen and fishermen ended up in the water. Charles Knapp, owner of the resort, grabbed some boards to use as a raft and swam out to bring the fishermen and pilot to shore.

"The Dawn Patrol" was started in 1939 by Whit Ansley, circulation manager of the *Fort Myers News Press*. It was a twenty-four-hour news delivery service to the islands. The planes were flown by Carl Dunn during the winter season. His was the only airborne newspaper route in the United States. He zoomed over the coast and dropped newspapers near hotels and motels.

Bombers and gunners were supposed to wait until they were well over the Gulf of Mexico before starting to fire. Yet one time, a plane began shooting miles away as it passed over Punta Rassa. Some bullets made holes in the roof of Webb Shanahan's home, and some splattered the rainwater tank at Rosa Bryant's. Rosa was washing her hair when the

A postcard of Casa Ybel Resort from the 1940s. *Courtesy Sanibel Public Library.*

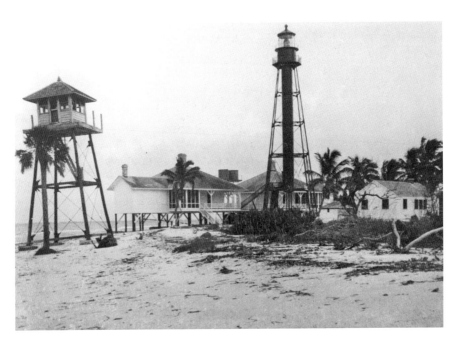

Lookout Tower at Sanibel lighthouse was built during World War II. *Courtesy Sanibel Public Library.*

bullets hit the roof and rolled into the gutters. She shrugged and said, "It's too late now to duck" and finished washing her hair. Bullets were found for a couple years afterward.

During the war, electricity came to the islands, and all the residents had to be fingerprinted. The ferry *Islander* was also requisitioned by the government and, in 1942, became the transport to shuttle troops. Islanders seldom left because the roads on the mainland were terrible and few had any gas.

The curtailment of ferry service and lack of gas and tires, plus bad roads, caused islanders to turn to the *Santiva* mail boat for relief. It never failed to arrive, good weather or bad. Folks could ride upriver one day, shop the next and return the third. Also the mail boat folks would make purchases for anyone on the island and deliver them to the landing.

William Reed, postmaster, gave up his position, and Scotia Bryant took his place. Her office was a tiny building built by the Kinzie brothers on Ferry Road. During wartime, no aliens were admitted, but that didn't stop some from trying. One night, Cuban fishermen stole a dinghy from the fishing smack on which they were working and landed on Sanibel. They hid the dinghy and themselves in the marshes behind Point Ybel. In the morning, the captain of the fishing boat reported them to the Coast Guard at the lighthouse. The fugitives were captured in an orange grove not far from the Bailey Store.

CHARLOTTE KINZIE WHITE

Charlotte Kinzie was born in 1914 in Fort Myers, Florida, to Captain Andrew Kinzie and Charlotte Eyber. The Eyber family were residents of Captiva as far back as 1887. Charlotte graduated from Fort Myers High School in 1932 and Florida State College for Women in 1936. Charlotte earned her certificate for medical technology from St. Luke's Hospital in Bethlehem, Pennsylvania, in 1937, and during World War II, she enlisted and served as an active duty officer in the U.S. Navy from 1943 to 1946. She served as a medical technician at the U.S. naval hospital in Portsmouth, Virginia, and remained in the reserve until 1957.

Long before Sanibel had a ferry, Charlotte and her father took his steamer down the river delivering cargo and passengers to the Matthews Wharf. She grew up on Jackson Street in Fort Myers but had fond memories of Captiva. Her family spent every summer with her grandmother Eyber in the cottage known as Snug Harbor: "There weren't more than fifteen

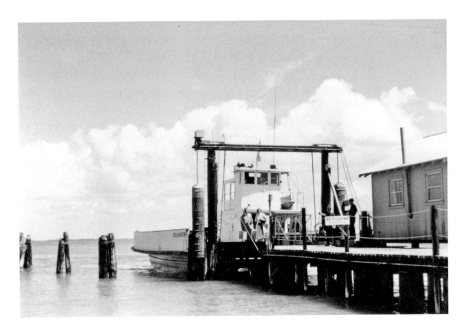

The ferry at Punta Rassa. *Courtesy Sanibel Public Library.*

or sixteen people in those days, mostly caretakers for the winter residences. We loved our freedom then; there was no South Seas Plantation or 'Tween Waters. Captiva was my first love."

In the winter, the atmosphere on Captiva changed. Charlotte had to wear dresses and be on her best behavior when the family visited their winter friends: "The ladies wore cotton or linen dresses or silk suits and hats. They entertained with afternoon coffees and teas and would show off their shell collections."

Following the death of her father in 1949, Charlotte returned to Fort Myers.

She worked in the family business, Kinzie Brothers Steamer Line, in Fort Myers and Sanibel until 1963. Her brother Ernest was now in charge, and she helped by manning the office at Punta Rassa. This ferry office served as a kind of chamber of commerce promoting the island.

In these years, Charlotte was living in Fort Myers but continued to spend a lot of time at the cottage on Captiva. Since the commute from Captiva was so long, she decided to sell the cottage and buy a home under construction on Sea Grape Lane. "It was the first home built between Ferry Road and Bailey Road."

This cottage was the nucleus of the Casa Blanca apartment complex that she and her husband built in 1968. "We were trying to build up a ferry business and develop some of the land over here, which none would appreciate hearing today."

Casa Blanca, 2011. *Photo by Manfred Strobel.*

After the bridge was built and the ferry went out of business, she and her brother and sister decided to buy a house, one of the first built on the island, on West Gulf Drive, the present site of the Atrium Condominiums. They called it the "Rat Villa" because of its terrible condition. They used it as a family retreat and then sold it.

About the same time, she met Duane White through some mutual friends. They married and moved to Rochester, New York, where Duane was working. Two years later, the couple returned to the island and built their apartment complex. In 1976, they sold the complex and built a home on Ferry Landing.

Both became heavily involved in the community, Duane as a planning commissioner and Charlotte as member of the Vegetation Commission and the Historical Preservation Committee. Says Charlotte, "At first I was not sure about incorporation being an old-timer and happy with the way things were. But I came around and am glad that it happened."

In later years, she complained that the island was being called "a rich man's playground" and hoped that young people of modest means would have a chance to come and stay on Sanibel.

She moved to Charlotte County in 2001 and died at the age of eighty-nine in 2004.

ROSA AND SCOTIA BRYANT

Karl Bryant came to Captiva in 1901. He and his father bought land on Captiva and farmed it. Karl married Rosa Kennon in 1902 after her family moved to the island. They lived with their four children— Scotia, Granville, Kenneth and Robert—part time on Captiva but mostly in Fort Myers since they wanted the children to attend school there. Karl ran a theater and bowling alley until they returned to Captiva in 1936. Scotia was named after the doctor who delivered her, who apparently came from Nova Scotia.

Though Scotia was born on Captiva, the house her family lived in at that time would today be halfway into the Gulf due to erosion.

The Bryants moved to the lighthouse end of Sanibel in 1939. Scotia and her mother, Rosa, opened a tearoom, Casa Marina, which also acted as a waiting room for the ferry. The women served mostly lunches, and Rosa did all the baking. The restaurant remained open until the last ferry left at five in the afternoon.

A photograph of "old-timers" in the 1960s. *From left to right*: Clarence Rutland, Esperanza Woodring, Charlotta Matthews, Rosa Bryan, Arthur Gibson and Belton Johnson. *Courtesy Sanibel Public Library.*

Scotia Bryant's house/post office today. *Photo by Manfred Strobel.*

In the early days, there was no electricity, so the refrigerator had to be lit with a match. Many times, the soft drinks were warm, and leftovers had to be eaten by neighbors.

During World War II, the Coast Guard took over the lighthouse, and electricity became available to island residents. To get a new electric refrigerator, residents had to put their name on a list, but Rosa and Scotia never got around to it. One of their customers became very frustrated with the warm drinks and bought them a refrigerator.

Scotia worked at the post office from 1943 to 1967. At sixty, she was ready to retire. Even after becoming postmistress, she continued to help with the tearoom, which remained in operation until 1950: "When I first took over, only seventy-five people lived on the island in the summer, and there was very little mail. But it kept building with the times. And the work began to get hectic. Every week they'd change something, and you'd have to keep up with the times. But after you get so old, you don't change so easy."

DOROTHY PRICE WAKEFIELD

Dorothy Price was born in 1924 and grew up on Captiva, where her parents owned 'Tween Waters Inn. As a young child, Dorothy's best friend was Marie Dickey Kalman. She and Marie went to Sanibel Elementary and enjoyed bumping along on the washboard roads. At that time, the schoolhouse was only one room and sat in the middle of the island on Periwinkle Way. There were six grades, and it had two outhouses and one teacher. Dorothy's daughter Niki went to the same school years later, but by that time, it had indoor plumbing and two rooms. There were four children in her class: Sam Bailey, Dorothy and two others.

She claimed she wasn't a very good child and got into a lot of mischief. Dorothy had a little boat she used to like to row, and she and Marie would spend the whole day on the water, rowing from one end of Captiva to the other, and taking a picnic basket and roaming the island on foot. One of her favorite pastimes was hunting for pirate treasure after reading all the books about pirates coming to the islands.

Dorothy was in boarding school during the war years. After the attack on Pearl Harbor, she returned to help her mother, Grace, with the inn. By that time, there was a beach patrol, and island houses were heavily blacked out

One of the original cottages at 'Tween Waters today. *Photo by Manfred Strobel.*

at night. She heard later there were more submarines in the Gulf than previously thought. Dorothy talks about that time: "We were careful not to go on the beach at night since we might get shot."

Most of the Coast Guard boys patrolling the beaches were away from home for the first time. Dorothy's family would be sitting around after dinner when someone would knock on the door. It was usually one of the "boys" asking for a drink of water. Before too long, the whole patrol showed up. Their cook always made an extra pie or cake for the Coast Guard boys.

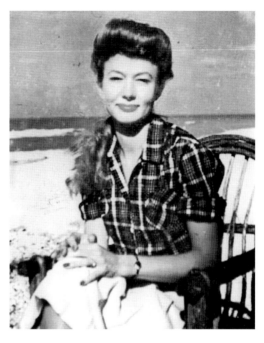

Dorothy Price Wakefield. *Courtesy* Sanibel Island Sun.

Dorothy met her husband, Johnnie, on the island. He was in the air force and was stationed in Venice, Florida. He transferred to Page Field and ran the air-to-ground target range on Bowman's Beach. He rented a cottage and lived on Captiva with his enlisted men. For Dorothy and Johnnie, it was love at first sight.

They had an island wedding at 'Tween Waters in May 1943. Some of the guests arrived by air force crash boat. One of the residents asked if she could give the wedding cake. She knew that the people in a bakery in St. Paul made beautiful cakes. The guest told the bakery that the wedding was a couple weeks before the actual day. She feared that the cake might get lost and figured a stale cake was better than no cake at all. As it turned out, she planned well. The cake, inexplicably covered in cinders, arrived the day of the wedding. The guests brushed off the cinders, sprinkled it with powdered sugar and found that it tasted fine.

Dorothy often spoke about the hurricane of 1944. 'Tween Waters was not damaged, but there was a lot of trash around. In those days, she could walk all the way up the beach to Redfish Pass. After the hurricane, there was so much beach erosion that she didn't know where she was going.

In an interview in 1990, Dorothy reminisced about her life on Captiva. After the war, she and Johnnie came back to the island to live. She became friendly with Penny Darling, a meticulous housekeeper: "I was not interested in housekeeping. Penny would comment on my large menagerie of animals and state that 'your place always has that lived-in look.'"

The islanders were all fond of the Coast Guard boys, and the ladies on Sanibel sponsored dances at the community center. Dorothy remembered Red Cross auctions where shells and homemade bread were sold. In 1983, Johnnie died on Captiva. Dorothy remained a viable part of the community until her death.

Chapter 8

The Islands' Popularity Grows

The islands of Sanibel and Captiva really came into the limelight after World War II. Renowned violinist Albert Spaulding gave a final concert from his home on Captiva in the spring of 1950. His wife, Mary, was serving tea to their island friends. Writers like Merrill Folsom of the *New York Times* called the islands the "Tahitis of the Gulf." Max Hun, in *All Florida Magazine*, named them the "Get Away from It All Islands."

In 1956, *Holiday Magazine* wrote an article about Sanibel featuring a seashell worth $2,500. *National Geographic* published sixteen pages of Sanibel's most exotic and colorful shells. Even *Reader's Digest* published a condensation of Anne Lindbergh's book *Gifts from the Sea*, reportedly written on Captiva.

To add to the notoriety, cartoonist J.N. "Ding" Darling, a Captiva resident, built a unique "Fish House," which was a studio in the middle of the bay accessed by wharf and drawbridge. Wanting solitude, he just pulled up the bridge. Residents honored the privacy of these famous people, never giving them much notice.

In June 1950, the Intercounty Telephone Company connected a telephone line at Ferry Landing. Pontoon seaplanes taxied up to shore, and in 1953, Casa Ybel had its own grass airfield. The possibility was also discussed of connecting all the islands up and down the west coast.

Sanibel mosquitoes set a new world record when a lone trap collected 365,000 in one night. In 1955, the Mosquito Control District started to dig drainage ditches, working east to west.

Esperanza Almas Woodring

Esperanza Woodring. *Courtesy Sanibel Public Library.*

Esperanza married Sam Woodring after meeting him in Punta Gorda. A descendant of Terevo Padilla, the Cuban fisherman who set up fish camps on the shores of Sanibel, Esperanza knew everything about fishing the waters of San Carlos Bay and the Gulf of Mexico. She and Sam ran a successful guide business, and their reputations brought many northerners to the island.

A guide for more than sixty years, she never grew tired of spending lazy days on her boat. She tells many stories about rearing children on Tarpon Bay, especially trying to get them to school. Some days, the tide was so high that Esperanza piggybacked her sons, Ralph and Preston, to Periwinkle Way to get the bus. This account in Florence Fritz's book *The Unknown Story of World Famous Sanibel and Captiva* backs up her story:

> *Homesteaders of the Tarpon Bay area laid a plank path through the mangrove swamp around the shore of Carlos Bay and a small foot log across an opening near Woodring's, their children could walk around the bay to school. One little boy was late for school as his grandmother made him wait as they trudged through the jungles until multitudes of fiddler crabs scrambled with great and fearful clatter out of the way.*

Esperanza was born in 1901 on her parent's fish ranch on Cayo Casta. Her grandfather Terevo Padilla was a Canary Island immigrant and ran a "rancho," where he and workers caught, dried and salted fish for market. Sam was working for Terevo when he met Esperanza. Sam died in 1942, leaving Esperanza a widow with two children, some property, fishing equipment, no money and "whatever he had taught her." With that, she made a life for herself and her boys. She net-fished commercially,

hook-and-line fished for trout and acted as a fishing and shelling guide, working from her small boat.

She caught her bait the same way fisher folk have for millennia: by flinging a cast net, a circular net ringed by lead weights. When tossed, centrifugal force opens it up like a lasso. Then it drops, trapping fish within the mesh. It was a man's world, but she strode right into it, earning great renown among tourists and others for her skill and knowledge of local waters. She also babysat and cleaned houses, working until she was in her late seventies. Even after she retired, she still fished, if only from the dock.

Fish was part of her kitchen, especially mullet, which she fried, baked or boiled. Esperanza bemoaned the depletion of fish in Tarpon Bay in an excerpt from Robert Edic's book *Fisherfolk of Charlotte Harbor, Florida*:

> *I've been out there fishing for three or four days now and did not even lose a shrimp. That is unbelievable! I never thought I'd see the day that I could not go out on the head of my dock to get a mess of fish. There's too many fishermen. That is part of the game. Then the red tide kills a lot of fish. And the powerboats go over these flats where the fish lay their little eggs; they churn the mud up and kill the grass roots and stuff like that…I think that if a fish is left alone and the feed is here, I think they stay there unless something comes and disturbs then or the feed disappears.*

Esperanza died in 1992, leaving a fishing legacy that few on the island can match.

Florence Fritz

Florence Fritz was the first female mayor of Fort Myers when there were only three female mayors in the United States. For more than thirty years, her avocation was historical research and gathering pioneer stories, photographs and sketches of Florida's Everglades, coasts and islands. She was an executive in the Red Cross Disaster Relief for Florida and a social worker who mingled with the Seminole Indians, homesteaders and frontier families.

She loved Florida—southwest Florida to the Everglades, the islands and all the creeks and rivers, as well as the Gulf of Mexico. For eighteen years, she edited and owned *Hello Stranger*, a magazine she founded in 1944 to welcome World War II military to southwest Florida.

The Unknown Story of World Famous Sanibel and Captiva was her fourth book, and she commissioned Eleanor Clapp to do the illustrations. At that point, the Clapp family were part owners of the Island Inn. Eleanor's aunt Charlotta Matthews was manager. Florence died in 1969 before having her manuscript published. Her good friend, Lelia Cunningham, took the time to put the manuscript together and have it published in 1974. A year later, the successful book was reprinted.

Lelia had so much respect for Florence that she climbed over enormous obstacles to have the book printed. No publisher was interested. Out of patience, she used her own money. According to Lelia, in 1969, when Florence knew she wasn't going to live to see her manuscript published, she took it to Egbert Smith of the Fort Myers Travel Agency and asked him to have it published: "She handed it to him with that funny little smile she often had and said, 'You will have this published, won't you? And see that I get credit for it.'"

Unable to finish the project, he gave it back to Lelia. "This is a little love thing for me. I did it for Miss Fritz and the community," stated Fritz's friend.

In an interview for the *Island Reporter* in 1974, Lelia Cunningham, eighty-nine, talks about her friend. She first met Florence Fritz in 1941, and the colorful and controversial Fritz was a frequent visitor to her home on Cleveland Avenue. For a few years, the Cunninghams left the area, but following the death of Leila's husband in 1952, she returned to Fort Myers, bought back her house and resumed her friendship with the author. Florence spent three summers at her house and finished three books. In the winter, Lelia taught piano classes, but in the summer, Florence and her electric typewriter once again took up residence in her home.

Writing the book was as much of a battle for Florence as publishing it was for Lelia Cunningham: "Florence had that cracked vertebrae in her back. And she wrote most of the book when she was propped up in bed on a board. Then she gave the material to me to edit. I'm the old school and believe commas shouldn't be there unless they have a purpose. I'd take them out, and she'd put them back in. How she loved her commas!"

Florence was a perfectionist, and before she died, she even designed the dust jacket. Lelia's printer stated that he'd never seen a book that well laid out, with the pictures all labeled and positioned. In 1974, Florence Fritz's sister, Dorothy Blackman, gave the Sanibel Library all her sister's files and photos, claiming that Florence had used it extensively for her research so she'd want the library to have the materials.

BETTY SEARS AND EVELYN PEARSON

In 1954, hospital dietician Evelyn Pearson and her friend Betty Sears operated the Casa Marina restaurant. Betty, whose family owned a business on Sanibel, had invited Evelyn to visit. The no-see-ums must have bitten hard because she fell in love with the island. After Ernest Kinzie spoke to the women about taking over the restaurant, they expanded the menu, offering everything from peanut butter sandwiches to full-course dinners. The success of this restaurant led to the opening of the Nutmeg House on West Gulf Drive, which was an island institution until the late 1980s.

According to an interview in 1992 that was part of the Sanibel Oral History Project, Betty stated some of the reasons for opening the restaurant: "Most of the places were not open on Sunday. We saw a need to provide food on demand. In the summer, the Island Inn was closed, and the owners of the cottages needed a place to eat. Jack Cole's was our closest competition, so we decided to open up in 1954. Everyone loved it."

This restaurant became a popular spot for folks to wait for the ferry. It was surrounded outside by sea grapes and Sabal palms and then mysteriously a telephone booth appeared. The food was so good that no one minded waiting for the ferry.

The women paid thirty-five dollars a month to rent the building. Besides providing a service for the ferry, there was also a need for bathrooms and a place for people to get away from the mosquitoes. The restaurant was open from 8:30 a.m. to 5:30 p.m., during ferry hours, and closed on Thursdays. Charlotte Kinzie rented

Evelyn Pearson. *Courtesy Sanibel Public Library.*

them a house for fifty dollars a month, which was part of Casa Blanca. Because of the restaurant's popularity, they needed help and hired Lena Billheimer. But some of their hires had an interesting work ethic. One employee, a supposed cook, sat under a tree reading the society pages. Evelyn joked about their first dish washer. "He was a high school student who was our first waiter and dishwasher. When he washed the dishes, he gave them three swipes around." Finally they hired two girls from off the island who waited tables and washed the dishes. The restaurant lasted for three years.

The mosquitoes were extremely ferocious. If people were using the telephone in the shack behind Casa Marina, they'd have to swat them away while talking. When the telephone came to the east end in 1954, there were twenty-four islanders on a party line. If anyone needed a doctor, they'd pick up the phone to find out if there was a doctor in any of the cottages.

Betty used to like to tell storm stories: "In 1949, the Billheimers owned the High Tide. The road to their place was all dirt and sand, a real washboard. Once, there was a bad storm, and Tarpon Bay Road was underwater—so much that one fellow even caught a fish. And if you wanted to travel up or down Rabbit Road you needed a good boat."

Ernest Kinzie was a little tight with money and didn't like to spend it on the restaurant. One day, Evelyn and Betty told him they couldn't run the

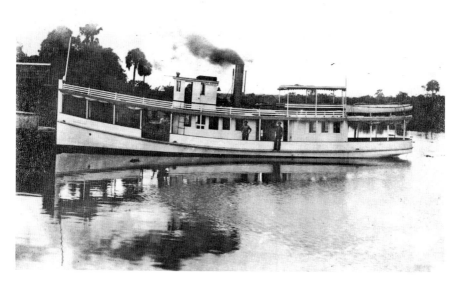

Kinzie Steamer. *Courtesy Sanibel Public Library.*

restaurant unless things were upgraded. They needed an electric dishwasher, a new roof and other things. Before Ernest laid out the money, he wanted them to sign a ten-year lease. They refused and decided to build a new restaurant on the Gulf.

However, most people living on the water didn't want a restaurant near them and were not interested in selling any property. Finally, Betty Sears's mother gave them the land to build on. It was a quarter mile from the High Tide condominiums, so they asked their neighbors for approval. The folks had no problem as long as there were only meals at night and no liquor.

By 1975, the popularity of the Nutmeg House had been so overwhelming that the women decided to enlarge the facilities. Island families, such as the Wiles and Gavins, worked in the restaurant, and it became a training base for the children. Timmy Wiles eventually opened "Timmy's Nook."

Since there was no bank on the island, residents were one another's bankers. One time, Francis Bailey ran out of cash and borrowed some from Evelyn. He'd promised to pay her back the next time he was able to get to his bank in town.

The majority of their customers stayed at the High Tide. Evelyn and Betty would make sure there were toys in the corner for the children when they were waiting for their dinners. Most of the time, the children were good, but occasionally, a family was asked to leave because of their children's bad behavior.

One of their worst experiences was the hurricane of 1960, Donna. They had to evacuate the island, and it was days before they could return. "There was no electricity anywhere in Florida for weeks. There was terrible damage on the island, but our restaurant and the High Tide fared well."

Eventually, Betty and Evelyn sold the restaurant, but while they owned it, the Nutmeg House received numerous accolades from the local papers. Over the years, it has changed ownership, but it was Evelyn and Betty who had the foresight to bring a gourmet restaurant to paradise.

The Bridge That Changed the Island

Hurricane Donna devastated the islands with sustained winds of ninety-two miles per hour on September 10, 1960. Australian pines were tossed around like sticks, power lines blew down, docks were swept away and, in some places, electricity was down for twenty-six days. There were no fatalities.

In contrast, the civil rights movement came quietly in 1962, integration beginning when St. Michael and All Angels Episcopal Church's Reverend Thomas Madden announced he would no longer serve a segregated congregation and invited the first black family to baptize their son and become members of the church. In 1963, the parents of the students at Sanibel Elementary School, then all white, requested total integration, and Sanibel became the first integrated school in Lee County. A year later, the Sanibel Community Association dropped the word *white* from its requirements for membership, and in 1970, Carl and Mozella Jordan became the first black members.

The islands were also progressing in other ways. In 1963, Hugo Lindgren finalized his dream of a bridge from the mainland to Sanibel. In the 1950s, he had bought a Gulf-to-bay parcel on Sanibel and proposed the bridge to aid development of the property. Over the objections of many islanders, he built the bridge that changed the island.

The Island Water Association was formed in 1965, bringing treated water to the island from Pine Island. Two years later, Lee County hired a planning firm from Georgia to develop a county-wide comprehensive plan. The zoning proposed for Sanibel sent shock waves through the island community. Buck Key and all of Captiva were recommended for high-rise,

Sanibel Bridge in the 1960s. *Courtesy Sanibel Public Library.*

heavy-density construction, as was most of Sanibel. A four-lane highway was proposed to bisect the "Ding" Darling Refuge. If fully developed, the population of the two islands would grow to 100,000 people. Islanders immediately formed the Sanibel-Captiva Study Group.

Developers moved quickly, and the Lee County commissioners were divided about issuing height and density rules for Sanibel and Captiva. Incorporation became the word of the day. On March 27, 1974, 55 percent of voters favored a referendum vote for incorporation in the upcoming November election. Developers flocked to the county for building permits prior to the vote. On November 5, 1974, 84 percent of Sanibel voters went to the polls, 63 percent in favor of incorporation.

Women joined their husbands, brothers and fathers to organize and help the new city take shape.

MARIEL GOSS

As a young mother on Sanibel in 1972, Mariel Goss and her friends were concerned with the number of construction vehicles racing up and down Periwinkle Way. On behalf of bike riders, she and others jumped

Mariel Goss. *Photo by Chauncey Goss.*

through endless political hoops to get Lee County to provide bike paths on the island.

At that time, the small path in front of the Sanibel Community Center was the only safe place to ride. Mariel was encouraged to act after reading an article about a woman who had been instrumental in getting the Washington, D.C., to Mount Vernon path built. She and her friends Grace Whitehead and Sherry Vartdal went to the sheriff to plead for enforcement of the speed limit, but he ignored them.

The women then organized a 501(c)3 association and raised money by selling buttons and T-shirts to support the effort. Next, after a call to Tallahassee, they learned the correct width and amount of asphalt for a trail and that there was no state funding available. Undaunted, they formed the Sanibel Bike Path Committee to work toward the creation of a system of "hike and bike" trails for the island. The group adopted a slogan: "Preserve, Protect and Pedal." Mariel tells how she and "the girls" fared with the commissioners: "In 1973, we thirty-something Yankee girls went to the very southern Lee County commissioners to plead for help. The presumptuous county officials dismissed the idea and told us 'to just head back to our elitist island.'"

That November, Commissioner Goldtrap rejected bike paths as a "priority for toll receipts," and that same month, a staking test was done for the trail but was stopped, pending the outcome of causeway revenues.

In February 1974, to get the attention of the media, the growing group of islanders staged a "bike in." Women and children rode slowly down Periwinkle Way, stopping traffic. The media took note.

The day after the demonstration, island cyclists went to the county courthouse to hear about a master plan for a countywide network. Commissioners claimed that paths would have to be built with state or federal funds. In April 1974, the county commission approved a community services director to proceed with laying out, striping, placing signs for and paving a four-foot bike lane.

In June, county commissioner Ben Pratt said plans were proceeding well enough that the job should be completed in three months.

In October, the state had $2 million in federal funds earmarked, but by the time it got to the county, it had ended up in secondary road fund coffers. Money was the main obstacle in building the paths. Awareness of the problem was the key, and Mariel and her group decided to advertise. Bike rodeos, decorated donation jars in local stores, Art in the Afternoon, "buy a foot on the bike path at $2.00 a foot," cookbooks, bells, flags, raffle benefits and buttons were part of the campaign. Their persistence was rewarded in 1976 with the completion of the eight-foot-wide path from Causeway Road to Tarpon Bay.

Grace Whitehead

Grace Rossiter was born in New York in 1918. When she was ten, her mother, who had birthed thirteen children, took to the bottle, and Grace and her elder brothers and sisters were placed in state custody. She ended up in a castle on the Hudson River in Yonkers. It had been converted into an orphanage. "You went to school there until 8th grade, and then you were presumed to be on your own. I stayed until I graduated from high school, since I could cook," stated Grace in an early interview. After high school, she went to cook for "an old folks home" and lived there while saving money for nursing school. She graduated in 1941 and was hired to run the maternity ward. A year after Pearl Harbor, she found herself aboard the *Algonquin*, one of two hospital ships the army sent overseas.

Grace saw a lot of changes during her well over thirty years on Sanibel, but her pre-Sanibel life was also interesting. A member of the armed forces during the war, she would have been a major had she remained in the military. As a first lieutenant in charge of a psychiatric ward on a hospital ship, she had proved her salt. But she fell in love with an intelligent and charming administrative officer aboard that ship. And one day after leaving that vessel they were married in New York City: "We went to see a Supreme Court justice to get a waiver for the New York law that said you had to wait seventy-two hours to get married. He was in his robes, and he looked at me and said, 'What's your rush?' and I said, 'I've been living with this man on a hospital ship for two years; don't you think it's time we got married?' and he said, 'Yes, ma'am.'"

The couple arrived on Sanibel Island in an over-cab camper in the spring of 1969, with Don's mother, a poodle and a parrot named Juju. Don had retired from the CIA and wanted to go somewhere warm and quiet where he could do freelance writing. Researcher that he was, he'd contacted the chamber of commerce and received a letter from Priscilla Murphy. Grace tells the following story: "We'd been two days en route from Sarasota to Fort Myers looking for a condo, and we didn't like anywhere we'd seen. Don suggested we try Sanibel. When we met with Priscilla, she told us there were no condos on Sanibel, and there never would be."

They moved on but couldn't find anything they liked. The beauty of Sanibel encouraged them to give it another try. They returned and bought a lot on Lindgren for $6,100, and they built a modest one-story house with a swimming pool. After taking Don's mother back to Kansas, they returned for five months while their house was being finished and lived in the Muench's trailer park.

About the same time, Porter Goss, who had worked for Don in the CIA, moved to the island. Goss and the Whiteheads started a boat rental business at the Sanibel Marina. "We didn't know much about the business, only that the pointy end of the boat went forward," stated Grace. During those first couple years, Don and Grace enjoyed getting to know fellow islanders at the once-a-month potlucks at the Sanibel Community Center. "Everybody knew each other—it was delightful," she said. "Bailey's used to give islanders a card and then bill them once a month."

But by the early 1970s, it became clear that high-rises, traffic lights and strip malls were all very real possibilities: "Sanibel was going to be overrun with cement. Most people here resented the causeway to begin with. Then all these condos started, and Lee County didn't care what was being built."

Pond-Apple Bike Path on Sanibel in 2015. *Photo by author.*

That's when Don, Porter and others started the *Island Reporter* in response to a "demand from business and civic leaders for a newspaper edited on the islands for islanders." At that time, the only island newspaper—the *Islander*—was being edited on Fort Myers Beach.

Aside from generating support for Sanibel incorporation, the paper had a light-hearted spirit. Stated Grace, "It was fun—we really had a good time!" While Don literally wrote the whole paper at first, he did have one columnist whom he bamboozled into writing. Don had promised readers a column from Grace. "I told him he'd lost his mind—he could write, but I couldn't. He told me my problem was I was trying to be too intelligent. 'Just write like you talk.'"

The result was a column called "Scene on the Beach" that Grace wrote weekly. She always believed the *Island Reporter* played a big role in keeping islanders on top of the incorporation effort: "Starting a city is not easy, and I think we did a wonderful job—everyone came right to the forefront and really worked. I think the paper was vital in letting people know what was going on."

After the city was incorporated in November 1974, the Whiteheads continued to play a key role in its formation. Grace was even dubbed "Queen" of Sanibel in the city's first official Fourth of July parade.

She wore a cardboard crown and rode in a convertible that was followed by the *Island Reporter*'s kazoo band. The Whiteheads remained with the paper for eight years, over which time it peaked at more than one hundred pages a week and earned numerous awards from the Florida Press Association. "By then, the paper was well-established, and Don decided he wanted to travel."

After selling the paper in 1981, the Whiteheads cruised the world. But it was always lovely for Grace to come back home to the island. In 2005, she was proclaimed the first City of Sanibel Founders Day Honoree. She enjoyed many years on the island after Don died, until she passed away in 2011 at the age of ninety-two.

ZEE BUTLER

In 1974, a group called "Sanibel Tomorrow" was formed to work for Sanibel's incorporation. It was led by Zelda "Zee" Butler. The group succeeded on November 5, 1974. The next week, on November 1, Zee resigned from Sanibel Tomorrow so that she could run for the first Sanibel City Council.

On December 3, 1974, Porter Goss, Vernon MacKenzie, Zee Butler, Charles LeBuff and Francis Bailey were elected to the first Sanibel City Council.

Zee Butler was the first female mayor of Sanibel. *Courtesy Sanibel Public Library.*

Zee was born in Chester, Illinois, on February 9, 1926, and attended Brown Business College in St. Louis, Missouri. She worked as a secretary to a fashion designer and was a photographic model from 1943 to 1944. After moving to New Jersey, she served as vice-president of the Mount Claire League of Women Voters.

Settling on Sanibel in the 1960s, she owned and operated Dottie's Boutique from 1966 to 1970. Concerned about Sanibel's future, she served as secretary of Sanibel's Home Rule Study

Group until 1974, when she was elected to the city council and served from 1978 to 1981 as mayor.

Known for her theories on land-use management and growth control, she was appointed by the governor to the Florida Council on Criminal Justice. Zee also chaired the City of Sanibel's Below-Market-Rate Housing Committee and was an avid supporter of the arts. From 1973 to 1976, she was the executive director of the Fort Myers Symphony. Who knows what more she might have accomplished had it not been for her untimely death in 1981.

Aileen Roberts Lotz

Aileen was dubbed by Porter Goss the "Mother of the Sanibel City Charter" after she drafted a home-rule charter in January 1974. A professional consultant with many years of experience in government and a wide knowledge of city charters, as well as an acquaintance with the Florida power structure, she was hired by a group of residents on Sanibel.

She not only assisted in writing the charter but was also responsible for lobbying Florida state legislators for the emerging city, and she helped the Sanibel Tomorrow group get a positive vote in the November 1974 referendum.

In the report she submitted to the Home Rule Study Group on March 15, 1974, she "recommended that they pursue incorporation." Her report was unanimously agreed to on March 27. Five hundred residents met at the Sanibel Community Center to consider the report. Those favoring incorporation in ballots taken at the meeting numbered 430.

After helping Sanibel with its charter, she worked as director of Metro Miami's Department of Human resources, administrating a $45 to $60 million annual budget for health and social services. She always had two passions: birding and traveling.

Her life took a different turn after she traveled to Antarctica. Following her 1980 trip, she spent most of her time identifying birds that crossed her path. "Birding," she wrote, "was the best excuse for traveling." Her proudest moment was when she completed her book *Birding Around the World*. Research for this book took her on hikes through the jungles of Peru as well as to the rocks and ice of Antarctica.

MOZELLA JORDON

Mozella was born in 1933 in Florence, South Carolina. During high school, she was a majorette in the band and loved to play the piano and sing in the church choir. As a high school athlete, she played on the basketball team. She came to the island in 1950 to work with her mother at the Casa Ybel Resort. Under the direction of the head chef, she mastered the culinary arts, which led her to a career in catering. While at the resort, she met her husband, Carl. After she married Carl, they moved to Ohio for a few years and then returned in 1958, when she started her catering business.

Mozella was a crusader for equality in education for all island children. She was influential in the Sanibel School's becoming the first integrated school in Lee County, and she and her husband were the first black couple to purchase land on Sanibel Island. She was happy to join with other islanders to fight for the incorporation of Sanibel. Her son Timothy was the first black child baptized on the island in 1966.

As the first black caterer on the island, she fed residents and tourists alike. Her catering business had grown strictly by word of mouth, and with

Lily and Company Jewelry Store was once a school for black children. *Photo by author.*

the support of her son Jim, a member of the city of Sanibel Planning Board, she realized her dream. In 2003, she opened a take-out deli called "Mozella's Foodworks": "For the past thirty years I've gotten to know so many families, their children and grandchildren, and I've fed them all."

At the time, Jim proudly talked about his mother, who died in 2007: "This is the fulfillment of my mother's dreams and reputation, and it's a legacy that she will pass on to her children. She always wanted a place to hang out her shingle. Working from her home has been very difficult, and this gives her a base."

Her idea was to have a business that fulfilled a need on the island. Over the years, her clients had raved about her food. With the deli, more people would be able to enjoy it. Mozella remained very active in the community and was an integral part of the Zonta organization on Sanibel.

The year that she died, her granddaughters were awarded education scholarships from the organization. Her granddaughter Alicia summed up her grandmother's legacy: "She set an example and inspired us to believe in ourselves and our ability to achieve goals in life."

Chapter 10

Preserving the Islands' History

By the end of the 1970s, two groups were defining the future of Sanibel. Captiva had opted out of incorporation and found itself at the mercy of Lee County. But on Sanibel, the fight continued between the conservationists and the developers. Both would taste victory and defeat.

The city wanted to buy two strategically located pieces of land, the twenty-eight-acre causeway property at the entrance to the island for $1.75 million and the thirty-acre Brown or Algiers property with one thousand feet of Gulf-front beach for $1.3 million. It argued that the entrance to Sanibel should be noncommercial with a park, a public building and maybe a screened parking area in case Sanibel ever needed public transit.

The Brown property had a remodeled ferry boat with an interesting history. The Browns converted the ferry into an elaborate Mississippi paddleboat replete with marble bathroom fixtures, a chef's kitchen and elegant drawing rooms. It was probably the first mega-mansion on Sanibel, but Helen and Lathrop never lived in it. Lathrop died before they could move in, and Helen left the island, abandoning her new home. When she died in 1977, the city bought the property hoping to salvage the home. Deterioration had set in over the years. The boat was demolished, and the property was renamed Algiers Park.

In November 1978, 72 percent of islanders approved the Rate of Growth Ordinance (ROGO), making Sanibel the only city east of the Rocky Mountains to have a growth control law. The purchase of both tracts of land was also approved and financed by a Farmers Home Administration

Loan. The following year the city council accepted an amendment to the Comprehensive Land Use Plan (CLUP), which put certain restrictions on time-sharing resort housing.

By 1987, Sanibel and Captiva were feeling the pressure of a growing population. From October 1, 1985, to September 30, 1986, almost 2.5 million vehicles drove through the J.N. "Ding" Darling National Wildlife Sanctuary. In 1987, 7,000 dwellings had been built. CLUP had allowed for 8,900. There were about 4,400 permanent residents.

Inevitably, growth and rising real estate values were changing Sanibel. There was much more opulence and elegance than before. There was still resistance from the old-timers and idealists who were determined it should remain a different kind of place.

ELINORE DORMER

Elinore Mayer Dormer was born in 1918 in Erie, Pennsylvania, and arrived on the island for the first time when she was one year old. The two Mayer brothers, Ross and Martin, ended up buying bayfront property and built two Sears, Roebuck kit houses, Shore Haven in 1924 and Morning Glories in 1926, as vacation homes. Each year, Elinore's mother and father, Daisy and Ross, would return to the island with their five children for a respite from the cold. In an article Elinore wrote for the *Islander* in 1986, she describes her idyllic time on the island in 1930, before her family's business failed and her father died:

Elinore Mayer Dormer, 1947. *Courtesy Sanibel Public Library.*

When we arrived after the leisurely trip from Erie, Pennsylvania, we found everything as they had left it in their big Sears and Roebuck house, Shore Haven. The children were enrolled in the Sanibel School the very next day…there were about 28 students, and grade by grade, we would file up to the platform at the front of the room and recite our lessons to Mrs. Burnhans. Besides reading, writing and arithmetic, there were special projects, a school vegetable garden, an exhibit to be prepared for the Lee County Fair, and rehearsals for the school play which opened to rave reviews at the Community House.

She describes Sanibel as a very sociable place, with card games at night, fish fries and oyster roasts on the beach. Uncle Ernest Bailey loved the "the-ah-ta" and arranged presentations at the Sanibel Community House. Almost every Saturday night there was a dance, and just about everyone went, even the hotel guests, who were easily recognizable in white flannels and gay dresses.

After her father's untimely death, her mother sold their Pennsylvania home and moved the family to Sanibel because it was cheaper to live on the island. Elinore loved living and growing up on the island. She attended the University of North Carolina–Chapel Hill and graduated with a BA in English. Upon graduation, she joined the navy and became part of the war effort as an intelligence code breaker. During this time, she met her husband, Robert Dormer.

Upon retirement, the couple returned to Sanibel in 1962, built a home next to Shore Haven on the bay and raised three sons.

After the bridge was built, Elinore's focus was on preserving the island's historical buildings from the bulldozers, and she helped form the Historical Preservation Committee. This group was the power behind the formation of the Sanibel Historical Museum and Village in 1984. She also wrote a book, *The Seashell Islands*, in 1987, after extensive interviews with island families and exhaustive research into the origins of the island's history.

She had many fond memories of the island: "When I think of Sanibel, I think mosquitoes and moonflowers. During the time when the moonflowers around our house were in bloom, we'd watch them close up each night before it got dark. And we just took the mosquitoes for granted. They lived here and so did we. We adapted."

In 1926, she was six years old when she started school on Sanibel. Island children didn't like the folks from up north, and they'd take sides when the discussion came to the Civil War. At that time, the boys were learning how

An aerial image of the Sanibel Historical Museum and Village from 2014. *Photo by Jim Anderson.*

to garden, and there were always bags of fertilizer along with jackets hung by the back door. Sometimes, the jackets smelled of fertilizer.

She was here when folks started planting Australian pines, and one time, she and some friends wandered off during recess and were late getting back. Realizing the popularity of the new pines, they were smart enough to bring the teacher a small plant and didn't get into trouble.

She reminisced about the day the family found a skeleton in the mangroves behind her house. She called her "Antonia" after the Calusa woman who was supposed to have married Spanish explorer Pedro Menéndez.

In February 1993, after Elinore resigned from the Sanibel Historical Preservation Committee, she received kudos from the City of Sanibel for all her work and was honored as the person who started the Sanibel Historical Preservation Committee and served as its chair. She was proclaimed "the island historian."

She was also noted as one of the islanders who helped formulate the historical preservation section of the Comprehensive Land Use Plan. On account of her efforts compiling the history of the Sanibel lighthouse, it was listed on the National Register of Historic Places. She worked tirelessly for the Sanibel-Captiva Conservation Foundation and was an early supporter

of the precursor to the Below-Market-Rate Housing Program. She and her husband, Bob, sold their home and moved to Seneca, South Carolina, where she died in January 2003.

BETTY ANHOLT

Betty Anholt. *Photo by Jim Anholt.*

Betty and her family had been vacationing in the area since the early 1950s. She remembers visiting as a thirteen-year-old and vowing never to live in Florida. But circumstances changed. She and her husband, Jim, moved to New Jersey after college, where Jim worked outside for a water company. In 1968, Jim was told to change jobs or move to a warmer climate for his health. Her parents had moved to Fort Myers Beach, and they came to the area with their two small children.

A year later, the family relocated to Sanibel. Jim, who had been working a night job at the Standard Oil Station next to the Bailey's Store, found himself in partnership with the owner, so he and Betty moved into the twenty- by twenty-four-foot manager's quarters. "When we first moved into the house, there was an alligator under the building," she stated. Betty did the accounting but worked next door at Elsie Malone's shell shop. After she and Jim became sole owners of the gas station, she continued managing one of Elsie's shops for seven years. "We owned the station all through the gas shortage and then sold it."

As a volunteer at the Sanibel Library, Betty was intrigued by the archaeology and history of the islands and began to research the subject. Jim became a board member of the chamber of commerce. The head of the chamber had an idea for a trolley. After the season in the early 1980s, he asked Jim and Betty to run a trolley service for a couple weeks on a trial basis. Its popularity encouraged the couple to do trolley tours all over the island,

and Betty wrote her first book, *The Trolley Guide to Sanibel and Captiva Islands*: "We did the first bird tours for the sanctuary as well as a couple of island tours a day. We ended up with three trolleys, and before long, we were giving history tours. So for five dollars, a tourist could ride from the chamber down the island to J.N. Ding Darling and back."

They gave up the tours because of the high insurance costs, along with the fact that they had to pay the city a franchise fee. "It wasn't economically feasible anymore. We should have given it up sooner." Now out of the trolley business, Jim joined the Sanibel Fire Department as a volunteer while Betty worked at the library and was appointed to the Sanibel Historical Preservation Committee.

In early 1984, the Sanibel Historical Museum and Village opened, and to showcase the new museum, Betty was asked to write a book about Sanibel's history, which she called *Sanibel's Story*. It took her two and a half years to complete the project.

> *It was great fun. At one point, my living room floor was covered with all kinds of notes and photos. I tried to sort through them all. So many of the photos were in bad shape. People had taken old pictures that had been scotch-taped to an album and thrown them all together, thus causing them to tear apart. We had a lot of wreckage. We made lists of people we wanted to interview. But then they would die, and we'd have to cross their names off. We were lucky we have the interviews and first impressions that we have.*

Betty teamed up with Elinore Dormer, using many of the oral history and photographs compiled for her book *The Sea Shell Islands* as the basis for her research. Though there were a lot of cassettes from interviews that Elinore had done, many were not usable or often couldn't be transcribed. But Betty persisted and was pleased with the finished product. Her book is still the basis for most other books written about the island's history.

Betty still works at the library and has been involved in digitizing photos and newspaper articles, thus ensuring the preservation of the island's history. Jim has retired from the fire department, and their two children live and work on the island. She continues to be the "go-to person" for information about Sanibel and Captiva.

RENEE BUDKE

In 1980, Philadelphia native Renee Budke and her husband, Bill, ready to begin the next phase of their lives, moved to Cape Coral. They realized their dream for only a short time before Renee's mom was diagnosed with Alzheimer's. "My mother was a concert pianist, and the last thing she could do was play Mozart. She didn't even know me. It's a terrible disease," she stated. Not too long after her mother's death, her beloved husband was diagnosed with the same disease. "He was very smart, and he knew what was happening."

Renee and Bill met and fell in love right before the Japanese attacked Pearl Harbor. Though Bill was in law school, the day after the attack, he enlisted in the navy and then married Renee. Bill, who was in the thick of the war, received the Silver Star for bravery in combat. After the war, Bill returned to law school, and Renee raised three children.

In 1991, after Bill died, she was looking for a new direction. That's when Renee noticed an ad in the paper for Paul McCarthy's Marina on Captiva. Paul had partnered with the Sanibel-Captiva Conservation Foundation (SCCF) and was running informative nature tours on his boat, *The Lady Chadwick*, and he needed tour guides. Renee signed up for the training session: "I was part of the second class, and we learned everything. Paul didn't want some kind of a spiel but wanted us to be able to talk about what we saw, birds, dolphins and trees, whatever. SCCF did a wonderful job training us."

Renee loved it and remained a tour guide for the next fifteen years, doing a couple tours a week. She considered it a privilege to work with SCCF and Paul. "It was what my soul needed. In the beginning I'd do the early morning tour, and we'd make kind of a breakfast with coffee and donuts. But that got to be too much." The tours lasted for two hours, some going to Cabbage Key and others to Useppa. She enjoyed talking to the visitors about the islands and the waterways. "The folks would laugh and clap when the dolphins jumped up. The more they clapped, the more the dolphins jumped. Everybody was happy."

At the end of each of her tours, as *The Lady Chadwick* tied up to the dock, Renee reminded everyone on board to look at the islands with their "island eyes." This expression Renee gleaned from one of her favorite books, Anne Morrow Lindbergh's *Gift from the Sea*. Lindbergh used the different types of shells on the beaches to reference certain feelings or phases in her life. Renee wanted visitors to look at the beauty of the islands using the shells as their "island eyes."

The Lady Chadwick today. *Photo by author.*

In her nineties, Renee moved to Shell Point Village. She seemed quite content to be among her favorite belongings in her private room and enjoyed talking about the islands and her days as a guide on *The Lady Chadwick*. She felt like part of that family since the captains whom she worked with came by to see her at Shell Point on a number of occasions.

"I loved being a volunteer and meeting all those wonderful people while doing the excursions. I enjoyed it so much, I would have been willing to pay them!"

MARY GAULT BELL

Mary and her first husband, Joe Gault, were the original owners of the Seahorse Shops and Cottages. Transplants from Detroit, they arrived on Sanibel in 1952 with their two children. With $4,000, they opened a small gift shop at the east end of the island to showcase the jewelry that Joe designed. Their open-air shop was so friendly that when they went

Seahorse Shops, 2011. *Photo by Manfred Strobel.*

out to lunch, they'd leave a sign: "Take what you want and leave the money"—and people did!

Mary's house was on the Gulf, and the mosquitoes were very thick. The children would cover up and run to the beach, rip off their clothes and jump into the water in their bathing suits. Then they'd do the reverse: dry off, jump into their clothes and dash back to the house. In the summer, when they woke up in the morning, they thought it was still dark because the mosquitoes covered the screens.

Mary claimed that though she was one of the residents who didn't want the bridge, it was a good thing. She recalled an instance before the bridge was built when one of the islanders had to be rushed to the hospital in Fort Myers. All the folks living around the air strip at Casa Ybel came out with flashlights so the plane would know where to land. She talked about how safe everyone felt on the island: "One night, during a storm, the shutters of their store blew open. Since they were living on the beach, it was the middle of the morning before they arrived at the store. Although the shutters had been open all night, nothing was taken from the store."

As one of the founders of the Sanibel Historical Museum and Village, Mary signed on as a docent involving herself with the training programs at the museum for many years.

Mary Gault Bell. *Courtesy of Deb Gleason.*

She was also an integral part of the community and, with Priscilla Murphy, was one of the original founders of St. Isabel's Church. She also wrote for the *News-Press* and served on the boards of CROW and BIG ARTS for fourteen years. A few years ago, she returned north to live near her children after the passing of her husband.

ANN HAYFORD BRUNING

Ann, a longtime Captiva resident, community figure and conservationist, was a finalist for the Paulette Burton Lee County Citizen of the Year Award in 2008, a year after she died.

She came to Captiva with her parents from Evanston, Illinois, in 1938, when she was ten years old. Her parents were longtime friends of "Ding" Darling and Andy Rosse. After the family's first visit, they returned in 1944. Her parents, Max and Jean Hayford, were among the founders of the Lee County Electric Cooperative.

Her father was told by his doctor to find a warmer climate, so the family spent winters on Captiva, living at 'Tween Waters. As the Evanston weather worsened each winter, they decided to leave the area and bought property on Captiva. Her father's first project was to build a pump house for their own property, which stretched from the Gulf to the bay. Max set up shop on the beach across the street and cast his own bricks using sand and cement.

She considered her childhood on Captiva as a time to sow the seeds of curiosity and encouraged her children to do the same. Ann left the island to pursue higher education and received a chemistry degree from Converse College in Spartanburg, South Carolina, in 1950. That same year, she married Chuck Bruning, but in 1981, she returned to her beloved paradise.

She was known as the volunteer in the shadows who quietly started the Captiva Library, even doing a year's stint as the librarian. She was also a member of the Sanibel-Captiva Conservation Foundation and the Captiva Civic Association. Ann loved the outdoors and was part of the movement to preserve Buck Key. She even took people on kayak trips to raise money for the purchase of the island.

According to the current librarian, Ann Bradley, "If you look through library archives, you seldom find her picture or even her name, yet she volunteered for over twenty years."

Culture and the Arts Expand

Even in their infancy, these barrier islands drew people interested in the arts. European-trained pianist Julia Dickey wanted a piano to practice on, local fisherman Andy Rosse entertained his customers with a guitar and internationally known stage actress Ruth Hunter bought the old schoolhouse, turned it into a theater and produced one-act plays. The visual arts were also represented by critically acclaimed lithographer Maybelle Stamper, whose reclusive life in a cottage on the beach on Captiva produced works that flowed with sensuous lines and unusual colors.

By the 1970s and 1980s, various cultural groups organized as a way of sharing common interests. In 1979, like-minded individuals formed the Barrier Island Group for the Arts (BIG ARTS), holding concerts on the beach, classes at the Sanibel Community House and displaying members' works in local art galleries. As BIG ARTS' reputation grew, residents and tourists flocked to different events. It became obvious that the organization needed its own home.

In 1987, after the City of Sanibel agreed to provide land, a local builder was convinced to donate one of the original Colony Resort duplexes slated for demolition. Backed by a cadre of dedicated islanders, the group raised the $75,000 necessary to move the building to its present site on Dunlop Road. Gifting the building back to the city and renaming it "the Founders Gallery," BIG ARTS began its first season of concerts, classes, discussion groups and juried art shows. The larger events were held on an outside deck.

Community response was overwhelming. In 1990, fundraising efforts began for an addition. This need became even more apparent during a Christmas cold snap, when Carrie Lund Productions was forced to cancel four shows, and eighty-five-year-old Carnegie Hall pianist Art Hodes had to perform on the outside deck in frigid conditions.

Lavern and Bill Phillips, members of the group since 1985, were responsible for raising the money needed to build a new wing, named the Phillips Gallery in their honor.

Also, local theater was coming into its own on Sanibel at the Pirates' Playhouse as well as 'Tween Waters Inn on Captiva, where J.T. Smith and his troop were performing comedic musicals.

FAYE GRANBERRY

Faye Granberry was born and raised in Louisiana. She exemplified the strong, independent women of the South. Her grandmother, a part Choctaw

Faye Granberry. *Photo by author.*

Indian and tribal doctor, taught her the use of herbs, and her mother instilled in her the love of gardening.

She tried to pursue a master's in horticulture at Rutgers University in New Jersey, but the administrators had other ideas. "No woman studies horticulture," they told her. She turned to psychology, received her master's in human relations and then enrolled at NYU for a doctorate. During this time, she spent a number of years modeling for Revlon cosmetics and was known as the Revlon Lady.

Faye went on to create many innovative programs for the New Jersey Court System—not the least of which was the Juvenile Offenders program that eventually gained praises from President Reagan. The mother of three, Faye retired after twenty-three years with more than five hundred volunteers in the Union County Juvenile Offenders Program, which eventually expanded to other parts of the state.

When she arrived on Sanibel, she was burned out. She bought her father's home, rebuilt it and landscaped it with native plants. Interested in architecture, she designed a beautiful master bedroom addition. Never losing her love for plants and flowers, she formed the Horticultural and Orchid Societies on Sanibel and became a master gardener. For eight years, she performed a Friday morning gardening show on WINK-TV.

An avowed conservationist, Faye was concerned that the younger people on the island had no time for or interest in preserving the pristine parts of the island. Faye was very specific about being a woman in society today. "There's a time and a place to be assertive and independent and another time to be soft and caring."

RUTH HUNTER

Ruth and Phillip Hunter, professional actors from the New York City stage, bought the old schoolhouse building on Periwinkle Way after the new school was built in 1962. It was turned into the area's only continuously operating live theater.

After painting it pink, they ran it for eighteen years. They converted it to a ninety-seat theater, arranged in two tiers surrounding a square stage, and called it the Pirates' Playhouse. Ruth was renowned internationally for her role as Ellie May in *Tobacco Road*.

Ruth and Phillip Hunter preforming at Pirates' Playhouse circa 1965. *Courtesy Sanibel Public Library.*

Dusty shells and starfish hung suspended in a fishing net draped across the curtained windows. The play always began with a scratched phonograph record playing "The Star-Spangled Banner." Just as the audience got to the "rockets' red glare," the needle jumped, leaving everybody half a bar behind. Ruth and her husband specialized in staging one-act plays and little-known British comedies. Their first production was *The Reluctant Debutante*, and tickets were two dollars. It was such an intimate place that if the play were a mystery, the audience would shout clues to the detective.

Ruth was all about helping the community. Many of the actors in her plays were locals, but she was also concerned about giving back to the community. In 1981, they held a benefit performance for the SOLVE maternity home in Fort Myers. Her motto was "If we can help save a life, it's worth it." The receipts for a full house for the special presentation of *Cyrus the Chore Boy* were donated to the home.

When Phillip died, Ruth left the island, and another group took over the playhouse.

LAVERN PHILLIPS

Lavern Phillips always referred to herself as a professional volunteer. Born in Cleveland, Ohio, in 1920, she attended Western Reserve University. In 1943, she met Bill, her husband for sixty-three years. Known to her grandchildren as Mimi, she loved to play the piano and was an active and lifelong volunteer and devotee of the arts.

Lavern began volunteering when her three children were young. Her family also hosted foreign students, which Lavern felt gave them the opportunity to learn about other cultures. After the children went off to college, she became a board member of the Minnesota Institute of Arts, the Minnesota Orchestra and the University of Minnesota. She was the chairwoman of the Centennial Year Celebration for the Minneapolis Institute of Arts, where she volunteered for thirteen years.

After moving to Sanibel, she and Bill became active in the Sanibel Community Church, Bill as a board member and she as a pianist. Lavern was also involved with the Southwest Florida Symphony Orchestra. About that time, Bill became treasurer for a little-known group called Barrier Island Group of the Arts. Soon Lavern joined the board and in 1989 became president. She and Bill served in these positions for thirteen years.

Bill and Lavern Phillips. *Courtesy of Phillips family.*

Lavern was instrumental in the growth of the organization from one small cottage to a campus with an art gallery, performance hall and multiple classrooms for various workshops.

Under Lavern's tutelage, the 150-seat gallery housed myriad programs. Locals could enjoy watching a ballet, listening to a jazz concert or learning how to paint with watercolors.

There were many other activities available at BIG ARTS, including ninety workshops and discussion groups, outstanding music and dance performances and forums made up of internationally known speakers.

Lavern was also the accompanist for the BIG ARTS Community Choir. Lee County Alliance of the Arts recognized Bill and her with an Angel of the Arts Award for Volunteers in 2004.

When asked in an interview why she volunteered, her answer was typical Lavern. "I felt I was one of the lucky people who could help ourselves by helping others." She was also given the Citizen of the Year Award by Committee of the Island (COTI) in 2002.

Lavern loved her time at BIG ARTS: "BIG ARTS is a happy place to be. You are always with a group of interested, interesting people who are highly motivated individuals. Cooperation is the keynote and there's never any stress."

She was still interested in everything going on at BIG ARTS until her death in 2013.

MAYBELLE STAMPER

Maybelle was born in 1909 in Dublin, New Hampshire. She came from a very creative family. Her great-grandfather was Moses Eaton, one of the most famous stencilers in New England. He'd travel around the area drawing houses of the most important people in the region. Her father painted and carved, and her mother carved and made braided rugs. If the family needed anything, they'd make it.

After graduating from the New Hampshire State Normal School in Keene in 1927, Maybelle pursued her interest in art. She studied at the Boston Museum of Fine Arts and the Art Students League in New York City and later taught at the Cincinnati Art Museum. She received several awards, along with high critical acclaim, and was considered one of the finest lithographers in the country.

The Old Blind Pass Bridge to Captiva. *Courtesy Sanibel Public Library.*

She first visited Captiva in the late 1930s with her husband, painter William Stamper. The remote island appealed to her, and a few years later, she became a permanent resident, living alone with her cats in a small cottage on the Gulf. Maybelle had only basic necessities in her home, but she had a telephone installed when her health began to fail.

She used rainwater to wash her clothes, and all the vegetables she needed were gown in her yard. If she required more food, she'd show up at the Island Store before it opened for the day to buy meat. She didn't want to be seen by the locals. However, most of the meat she'd bought ended up in her cats' dinner bowls.

Extremely protective of her privacy, she lived as a recluse in her cottage, befriending only a few who shared like interests. She didn't own a car and never learned to drive, relying on friends to take her to doctor or dental appointments. Maybelle would sell one of her works only if she needed money, and there were a few of her friends who kept her solvent for many years by acquiring her art.

Even though she enjoyed her privacy, she shared time with the island children, giving them art lessons. Over the years, Maybelle carefully saved many of their drawings between sheets of acid-free paper that she kept in a handmade portfolio. After her death in 1995, the preserved art was returned to many of these children, now adults with children of their own.

She was described by friends as having an existential life, her painting a reflection of her life's "songs and dreams."

Chapter 12

Success in Business

Throughout the history of the islands, women have been at the forefront of business. The list of female entrepreneurs on Sanibel and Captiva is endless. Some turned hardships into life-changing experiences, and others took the skills they'd learned and made profitable business decisions.

HELENE GRALNICK

In 1983, Marvin and Helene Gralnick opened the first Chico's store at Periwinkle Place on Sanibel Island. Transforming an old eight-hundred-square-foot tobacco shop, Marvin built counters, shelves and cubbyholes, and Helene designed the Chico's logo. They named the store after Helene's best friend's bilingual parrot, Chico, and began selling specialty folk art products from Mexico.

Along with the art, they tried a small sampling of cotton sweaters from Mexico. They were such "hot" sellers that the couple decided to forego the art and focus on clothing and related accessories. Two years later, Chico's opened its second store on the island of Captiva, and this one was quickly followed by more.

Although the first Chico's opened in 1983, the concept went back to 1970, when the couple lived in Mexico. Helene talked about the experience in an interview in the *Island Sun* in 1998:

Living in Mexico had a tremendous influence on us. We fell in love and learned to appreciate all the colors and textures of the country. We lived with cobblestone streets and ancient buildings.

We thought about living in Miami, but it's too much of a big city. We didn't want to raise our children there. We wanted a beautiful, clean, safe place, where we didn't have to lock our door.

The Gralnicks moved to Sanibel in 1980 and were involved in real estate. Running their own business was more appealing, and they signed a lease for the space at Periwinkle Place and headed to Mexico in a truck with no air conditioning that broke down a lot. Once in Mexico, they drove from village to village acquiring merchandise for the store. Their sweaters were such a hit that Helene and Marvin realized there was a market for clothing with natural fibers. At first, they sold other vendors' clothing, but they soon recognized that they could design and manufacture the items themselves, thus providing an exclusive product.

Marvin met a Turkish clothing manufacturer and made a trip to Turkey. At first, the clothes were solid colors, but eventually, the early Chico's signature look for "southwestern" evolved, based on the patterns of Turkish Kilim rugs.

One day a customer from Minnesota asked if she could open a Chico's franchise in Edina. Soon, other franchises opened. "It happened over and over again. There wasn't really a plan. We were able to grow with the franchises," stated Helene in the same interview with the *Island Sun*.

By 1992, Chico's had about sixty stores, including franchises, which helped fuel the expansion of company-owned stores.

A year later, Chico's became a public company, trading on the NASDAQ as CHCS. Eight years later, in April 2001, Chico's was invited to trade on the New York Stock Exchange as CHS.

Helene Gralnick. *Courtesy* Sanibel Island Sun.

In 1994, Chico's 107,000-square-foot world headquarters was built in Fort Myers. After selling the company in the 1990s, the couple returned to take leadership in 1994. After removing the chief executive, Helene and Marvin came out of retirement to revitalize the merchandise. Said Helene at the time, "We were excited to be again involved in the day-to-day operations."

After selling the business once again, they retired and now spend their time between their homes in Fort Myers, Captiva and Mexico. Their love for the community keeps them heavily involved, giving their time and money to local charities. In 2014, Helene and Marvin allowed Zonta to include their Captiva home for the club's "Peek at the Unique" fundraising event. Zonta awards educational scholarships to deserving children.

PRISCILLA MURPHY

Priscilla and her first husband, Pat, moved to Sanibel from Detroit after seeing an advertisement in a 1944 auto industry publication. Sanibel-Captiva was touted as the best place in North America to collect shells.

In 1955, she founded Priscilla Murphy Realty in the carport of her Sanibel home on Periwinkle Way. She wrote in her notes about the early days: "We had so few listings on the island that we even tackled Upper Captiva and Cayo Costa. To go there, we had to hire a boat and Captain Andy Rosse. He would explain where each piece of property was located but would never accept payment for his services."

Priscilla's first sale was a small stilt house on Donax Street priced at $880. Until 1961, when she hired a few sales people, she single-handedly ran the office. By 1969, the business had grown, and a salesman in her office achieved $1 million in sales. PMR's biggest sale was for $1.6 million in the early 1970s for two hundred acres in the Wulfert/Sanctuary area, formerly an old key lime grove. The only maps of Sanibel and Captiva in 1955 were small ten- by ten-inch sketches she traced from a map available at the courthouse in Fort Myers. This is the way Priscilla says she conducted business in the late 1950s and early 1960s:

> *The mail boat would bring passengers, and some would be dropped off at Sanibel until the boat returned from Captiva. One day, a couple from New York City stopped at Bailey's* [mail dock] *and walked up to the office asking if I would call them a taxi. There was no taxis; my transportation was a Jeep. I handed them the keys to the Jeep and said drive around. All*

Priscilla Murphy in the 1960s. *Courtesy Sanibel Public Library.*

they could do was look at each other tongue-tied. At last, the man said,
"They'll never believe this in New York." Needless to say, they returned the
Jeep on time and in good condition.

During the years when the island was underdeveloped and swarming
with mosquitoes, Priscilla would meet clients at the ferryboat dock and
snatch a handful of discarded bottle caps near the soft drink machine
before showing property. Since Sanibel featured such dense vegetation
and sandy soil, it was difficult to describe property by conventional
landmarks. She would drive her Jeep from government lot line markers,
carefully gauge the distance and stop at certain points to pound the bottle
caps into the sandy, shell-based road.

Priscilla was also dedicated to preserving the character of the island. This
is obvious in a story about a man who wanted to buy land in the subdivision
known as Gumbo Limbo: "The man was making an offer on the property
known as Gumbo Limbo, and he remarked that he needed a bulldozer to
pull down all the trees. My friend Peg Parcells and I were horrified. When

we told him that the trees would sell the lots, especially the beautiful gumbo limbo, he agreed and decided to name the subdivision after the Gumbo Limbo trees."

Divorced in 1960, Priscilla met her second husband, Leo Shelski, at St. Isabelle's Catholic Church on Sanibel. After a short time, Leo asked her to marry him; she refused, saying, "I just don't know you well enough yet." Leo proposed again on a cruise, and she accepted. They were married in Haiti in 1976 in a courthouse registry office.

She loved cats; one of her favorites was a seventeen-pound one named Caruso (he sang when meowing like his namesake Enrico). She also loved to dance, so Priscilla and her husband had a birch dance floor installed in their house so the two of them could dance all night to their favorite music.

In the early 1950s, Priscilla campaigned with her friend Esperanza Woodring to fund inside toilets for the children at the Sanibel School. Priscilla retired in 1972 after building a prosperous business. Her advice to those who want to be successful was "get off your duffs." In an interview for a local paper in 1982, she advised the young people on Sanibel and Captiva to buy all the land they could since it was going to become more and more valuable.

Katie Gardenia

Katie was born in 1943 next to the flour bin in her grandmother's restaurant kitchen. She spent her childhood in San Antonio and Cleveland. Her family originally came from Poland. Her grandmother, who was from a family of gypsies, instilled in her the fact that she should always have a home and inspired her to begin sculpting at the age of nine. She also taught Katie to read palms.

After she finished high school in 1962, Katie worked as a switchboard operator. After the death of her first husband, she needed money to raise her baby, so she began making handbags out of lunch kits. Patiently training other women in similar circumstances, the business grew into a small corporation.

Always a risk-taker, she started buying and renovating houses, and over the years, she has owned twenty-eight. Her second marriage brought her to Captiva in 1978: "Stunned by the beauty of the place, I wanted to buy a restaurant and turn it into a 'fern bar.' Jamie and I pursued the owners of a gift shop called 'The Owl and the Pussycat.' After many meetings, pleadings and bribes [her famous cakes], we came to an agreement."

Never having been in the restaurant business, the couple was clueless as to how to convert a gift shop into a restaurant. They had less than $20,000 to spend. Some of their money was used to buy an eight-burner stove that took Katie three weeks to clean. Wall decorations were old movie and theater photos framed in black along with treasured childhood toys. The final problem was lighting. With their bankbook empty, they decided to string up old Christmas bubble lights around the room. That's how the name "Bubble Room" was born. The five-train Lionel set was a last-minute addition.

On May 27, 1979, after placing flyers on cars in Bailey's parking lot, the restaurant opened. Katie baked and cooked for three days and was ready at 5:30 p.m., but it wasn't until 7:00 p.m. that the first customer arrived. By 8:00 p.m., the place was full. With their finances tight, they were lucky that local workmen frequently gave them extensions to pay bills or bartered for dinners at the restaurant.

One of Katie's favorite stories involves air conditioning, fish in a bag and a mayor. Soon after opening, the air-conditioning unit quit. With no money, the couple distributed hand fans to customers as a gift upon arrival. One of the items on the menu was called "Eddie Fishermen," an eight-ounce filet of black grouper with secret toppings, wrapped in parchment paper. One night after delivering the fish order, the waiter returned stating that the gentleman at table one wanted to talk to the chef. Fred Valtin, then the mayor of Sanibel, told Katie how he loved the fish but hated the presentation. He suggested she go to Bailey's hardware, get a number four paper bag used for nails and paint brushes and use that to bake the fish in. That's how "fish in a bag" was born.

In 1989, Katie and Jamie sold the restaurant, left the island and moved to Santa Fe, New Mexico. Things didn't work out for the couple. Katie, now single, returned to Captiva and supported herself by reading palms. She also started sculpting dolls, combining artistic talent with her love of the fantasy world. The dolls, constructed from all-natural materials, have jointed bodies that move. Not content with sculpting alone, Katie opened and operated Katie Gardenia's Mermaid Kitchen on Sanibel from 2001 to 2003. Now a sculptor of local renown, her gypsy spirit has taken hold again, and she's off to explore other places.

SANDY STILWELL

Sandy, owner and CEO of Stilwell Enterprises and Restaurants Group, has made Captiva her main base of operation. She has purchased and created RC Otters, Cantina Captiva, Sunshine Seafood Café and Wine Bar, Latte Da Coffee and Ice Cream Shop, Captiva Pizza and the Sunshine Grill in Fort Myers. S.S. Hookers, at the entrance of the Sanibel Causeway, is her eighth establishment and newest building: "Each of my projects becomes my [child], and the latest project is my favorite one. I didn't set out to be a restaurateur. But the business called anyway. When a resort investment was flailing due to poor dining numbers, I took it as a personal challenge."

Sandy Stilwell. *Courtesy Sandy Stilwell.*

Her original dream was to be like her father, Tom, and own a hotel. He moved the family to Fort Myers Beach when she was twelve. Sandy worked as a dishwasher in her uncle's restaurant and as a maid at her parents' hotel on Fort Myers Beach and then stepped up as front desk manager. By seventeen, she was managing the hotel. She talks about the hard times: "We were struggling. It was a family-owned business and ten others were being built at the same time. We rented our rooms for twelve dollars a night. Eventually my parents sold the property to Mariner Properties, the group that owned South Seas Plantation on Captiva."

In 1999, she bought her first business, the Captiva Island Inn, with its six rooms. The hotel came with a managing license on the restaurant next door. She purchased that two years later and renamed it Key Lime Bistro. "We're now up to seventeen rooms, and I built the shopping center for more parking." When Hurricane Charley hit in 2004, business on the islands came to a standstill. No one wanted to stay in the remnant of the storm. A

Key Lime Bistro. *Photo by Manfred Strobel.*

defining moment for her, she decided to diversify and opened her first off-island venture, the Sunshine Café in south Fort Myers. S.S. Hookers is her second off-island establishment.

Now that her two sons are grown, Sandy has more time to serve the community. Voted one of the Women of the Year in 2007 by *Gulf Shore Life Magazine*, she also received the First Annual Apex Award for Women in Business from the Fort Myers Chamber of Commerce.

She concedes that one of her greatest strengths is being able to hire good people whom she can trust to do their jobs. In 2015, she spent half her time doing charity work, primarily focusing on the lives of young people through health and education. President of the board of PACE Center for Girls, Sandy helped spearhead fundraising in order to improve the school's facilities. She is proud of her volunteer work as a trustee of the annual Southwest Florida Wine Fest that benefits the capital campaign to build the new Golisano Children's Hospital. Sandy credits her family as the secret of her success: "I have a great relationship with my parents. My mom is my cheerleader. Although in her day, girls didn't go to college, my mom handled our family business behind the scenes and provided good financial advice. They demonstrated a very hard work ethic."

In the Spotlight

Residents and visitors to Sanibel and Captiva can thank a group of women who have chosen to guide the future of the islands by being involved in policy decisions. Many have taken on the establishment and fought for their principles. Others have put their ideas forward in the public arena and become part of the establishment.

NOLA THEISS

Nola, a former English teacher, moved permanently with her husband, Hal, and two daughters to Sanibel after visiting the island for ten years. As the owner of Networks Cottontail Inc., a company that specialized in knitting and crochet translation and design, she was able to promote her craft books, as well as write a newcomer column for the *Island Reporter* in 1997: "We came in 1984 for the first time. I heard that it was a quiet place with shallow beaches and gentle waves. Our then four-year-old daughter had just had a near drowning experience in a swimming pool, and we wanted to give her a wonderful water vacation so she wouldn't be traumatized for life."

Nola loved the library and the friendliness of the islanders. It didn't take her too long to become involved in the community. She first joined Zonta and then became involved in island politics. With a master's degree in public administration and environmental policy, she was first appointed to the

Nola Theiss. *Courtesy Sanibel Public Library.*

Sanibel Planning Commission and then elected to the city council and, later, as mayor. During her tenure, she found herself embroiled in all kinds of controversies, especially the replacement of the bridge.

After spending four years in politics, she was ready for a new direction. She started volunteering with Zonta, where she learned about the horrors of human trafficking and was shocked to learn that this type of behavior was

happening in her own community. In 2004, she spearheaded a county-wide coalition to learn how to fight this problem. Aware of the importance of educating the public, she held events with service and faith organizations, law enforcement, human service providers and ordinary citizens. She helped to train and teach members of these groups to see the problems, figure out their roles and assume responsibility to correct it.

Nola's grandparents were emigrants from Poland, and she heard stories about how the Polish women were used as sex slaves. After reading extensively on the subject, she realized how vulnerable young girls and boys at the local malls are to these traffickers. She knew she had to do more: "Once we went to one of the local hospitals to tell staff what to look for with their patients. If a young girl came into the maternity ward with an older woman who wouldn't leave her side, look for a tattoo on the girl's arm or back with a name. That girl was a victim. After the staff was made aware, four traffickers were arrested a week later."

With Lee County's task force on human trafficking as the model, Nola has reached more than eight thousand people in communities around the country. Many victims have been helped, and task forces have formed in several states to draft legislation to address this issue: "I have no plans to retire. I already live in paradise, my adult children and grandchildren live nearby. I do not need a large salary, and I have a passion to do this work."

JUDIE ZIMOMRA

Before Judie Zimomra was hired as city manager of Sanibel Island, she was a former chief of staff for and served as executive assistant to the mayor of Cleveland, Ohio, for five years. Her law degree was also an asset when she served as director of public health and commissioner on environmental health.

Judie has served as city manager of Sanibel since 2001. An alumna of Harvard University's JFK School of Government's Program for Senior State and Local Officials, she has dealt with the recovery of the islands from Hurricanes Charley and Wilma and was named one of the Power Women of Lee County by *Florida Weekly*.

During Judie's tenure, the city of Sanibel has received two program excellence awards from the Florida City and County Managers Association (FCCMA). This association also selected for recognition the construction of the city's

Judie Zimomra. *Courtesy City of Sanibel.*

recreation center in the category of Community Sustainability and the restoration of the historical old schoolhouse at the Sanibel Historical Museum and Village in the category of Community Partnership.

Her accomplishments include reducing the tax burden on local property owners by obtaining more than $35.8 million in grants over the past ten years, as well as developing a user-fee system to recover costs for municipal services. The city also finished construction of a $14.5 million recreation center, and Judie oversaw the completion of a $73 million sanitary sewer and effluent reuse system.

Her academic credentials include a juris doctor degree from Capital University and a master's degree in public administration from Ohio State University with specialization in fiscal administration. She was selected as the 2012 commencement speaker for Newton Falls, Ohio High School, her alma mater.

Judie is best remembered for taking charge of hurricane relief in 2004 after Charley. Fortunately, the comprehensive plan had been reviewed just a few days earlier. Judie remembered the day in an interview in 2009: "At the moment I heard the storm was going to hit Sanibel, I was sitting next to the police chief. He was on the phone with a man calling from the Netherlands who was concerned that his 96-year-old mother had not left the island. The realization hit me that we might have fatalities. One of the most important things we learned was taking care of people with special needs."

When the city evacuated prior to Hurricane Charley, one hundred residents had decided to ride out the storm. Had the eighteen-foot storm surge occurred, that decision would have been fatal. Following the storm, Judie received an award from the National Hurricane Conference for outstanding achievement in public awareness.

Judie relishes living on the island, stating that one of the benefits of working at the city hall is observing the native birds, particularly the owls.

Sanibel Surfside Condominiums after Hurricane Charley. *Photo by author.*

She can often be seen on Sundays poking around the cases of fresh vegetables at the farmer's market and likes to buy the homemade guacamole. An avid biker and kayaker, Judie has a couple secret spots where she enjoys birding. A wonderful moonlit kayak tour of a rookery with the Tarpon Bay Explorers is a great way for this accomplished woman to end her day when she's not watching the sunset from the boat ramp at Punta Rassa.

Deb Gleason

Deb's family came to the island in the 1950s. Her father, Mike McQuade, worked at the Port of Baltimore for years. Tired of the same old rat race, he decided to move to Florida when Deb and her brother, Mark, were seven years old. In 1957, the family drove down the east coast of Florida to Miami and the keys. Deb's grandfather had always told them that Sanibel Island reminded him of Cuba, so the family boarded the ferry and headed for the island. When Mike saw the island, he remarked, "This is it."

They met Francis and Pauline Bailey at the dock and then were introduced to Priscilla Murphy. After a tour of the island, they bought five acres along

Deb Gleason. *Courtesy Deb Gleason.*

the Gulf for $36,000. The next year, they moved to the island and lived in the two-story house on their property while Mike built twelve cottages and named the motel Sanibel Siesta.

Says Deb about the motel, "We had some good years, and not so good." Her father had the first bike rental on the island. As kids, they thought they were very lucky to own a fleet of bikes.

Their business was brisk during some seasons. To accommodate the overflow, many of the cottages had roll-out beds and cots. Her father refused to build a pool, stating that the Gulf was in their front yard. However, if he wanted to compete with other motel owners, he had to put in a pool and add TVs in every cottage. Her brother learned his trade by helping their dad build all the cottages.

One of her funnier remembrances was about their cistern. Drinking water was a problem. The ground water was salty and good for showers, but no one wanted to drink it. Many of the islanders bought large bottles of water from Bailey's. Instead, the McQuades built a cistern and collected rainwater.

It was cement with a five-foot opening. Every year, she and her brother and sister had the job of cleaning the cistern. Their father would uncover the opening, and the children would jump in and float around on rafts scrubbing the sides clean. Apparently, they were quite noisy since one of their favorite renters, Phil Johnson, used to be amused when he entered the office and heard all this laughter coming from the floor. The floor of the office was over the cistern.

According to Deb, the two-story house they lived in was quite chic for the time. It had Mexican tile floors on the first level, and the second floor was all wood. The house was built of cypress wood, and the entire front was jalousie windows, which Deb had to clean. After her mom died and her father remarried, the motel was sold. Her father and his new wife bought land in North Carolina and spent their winters in Muench's trailer park.

The new owners of the property built condos and removed the second floor so as not to obstruct the view of the Gulf. The first floor was used as an office.

Deb attended Cypress High School, which was her first opportunity to go to school with any of the black families on the island. She wanted to attend college and see the world, so she went to the University of South Florida and then, after graduation, lived with a friend in Arizona before returning to the island. She worked at the *Island Reporter* doing all kinds of different jobs and even spent some time living on Useppa working as a landscaper. "I loved it."

When she went on vacation to Vermont, she met her husband, Brad. He had been to Sanibel once, and she encouraged him to return. Once he was back on the island, their relationship blossomed. They decided to go into business together and started "Caloosa Canvas," where they made luggage, director's chairs and tote bags—it was a typical island shop. Brad soon realized that while they could make a living and were able to rent a house on Sanibel, they would never be able to buy one.

One of their sidelines was renting party tents, so Brad found a job in Washington, D.C., and Chattanooga with a tent rental company. He would commute back and forth, or Deb would join him, make her bags and then return to the island to sell them in their shop. They did this for thirteen years. Once she became pregnant with their first son, Brad got a job on the island in the late '80s, and her life became normal. As the boys grew older and less dependent, she started another career—selling real estate.

Deb has always been involved with the island community. She was a member of the board of the Sanibel Community Association for seven years and worked in the gift shop at the Shell Museum. Milbrey Rushworth, who was doing displays at the Sanibel Historical Museum, asked for her help. Milbrey was a perfectionist, and Deb learned about the island through Milbrey, who had grown up on Sanibel. To her surprise, she was asked to replace Jody Brown on the Historical Preservation Committee, and once Sam Bailey stepped down, she became chairman.

"I have no idea why I'm chairman; I think of myself as an Indian, not a chief," she stated.

Now that the island is at buildout and the Sanibel Historical Museum and Village is complete, she talks about the future tasks for the Historical Preservation Committee. "We're still focusing on historic sites, planning a shared-use bike path and heritage trail." She's busy with her real estate business and continues to do the displays at the museum, but she looks forward to the time when others take up that task. "I love this island, it's my home. I don't want people to forget about its past and the early pioneers."

Chapter 14
Preserving the Islands' Beauty

The Sanibel-Captiva Conservation Foundation (SCCF) had its roots in Sanibel-Captiva Audubon—or, more specifically, the Jay N. "Ding" Darling Memorial Foundation of Des Moines, Iowa. It was created by the family and friends of Darling for the purpose of coordinating the groups formed after his death to further his aims. The primary goal was to establish a sanctuary on Sanibel. That memorial committee raised $25,000 from island residents to build a bird sanctuary and joined with the Darling family.

At the urging of Fish and Wildlife and Florida's Board of Parks and Historical Monuments, this committee was to serve as a guiding hand. It added to the emerging parklands such things as canoe trails, docks, a bridge and a tower dedicated to Alice O'Brien, former Captiva winter resident, whose interest and support furthered conservation causes.

In 1967, when it became apparent that the Fish and Wildlife Service would take over, islanders met with the directors of the foundation to discuss what would happen to funding. They were told that the Sanibel group would become inactive until a plan was developed for a refuge, which meant there would be no funding for Sanibel-Captiva Projects. The committee decided to go it alone. The memorial committee separated from the Darling Foundation, had its $25,000 returned and started SCCF.

EMMY LOU LEWIS

Emmy Lou and her first husband, Cecil Read, began visiting Sanibel in the 1940s with their three children. They purchased Gray Gables, the home of pioneer Laetitia Nutt, and then spent summers on Lake Michigan. Emmy Lou sold the home back to the descendants of the Nutt family, retaining a portion of the property to build a house and guest house. After the death of Cecil Read, she married Herbert Lewis.

She and Cecil were instrumental in founding St. Michael's and All Angels Episcopal Church. According to friend Evelyn Pearson, "She watched over us to see that all followed the proper church procedures. The church was always her primary interest and activity. She is considered the matriarch of the church."

Emmy Lou was the first president and chairman of the board of directors for the Sanibel-Captiva Conservation Foundation, which incorporated in November 1967. She was a part-time resident and ardent conservationist who supported Jay Darling. After he died, she and other islanders teamed up with the Sanibel Audubon Society to form a memorial committee, whose purpose was to raise money to continue the work Darling had started. At that time, there was a large parcel of land owned by the State of Florida, the school district and private owners. It was acquired by the U.S. Fish and Wildlife Service with the help of Emmy Lou and other islanders, and became the J.N. "Ding" Darling National Wildlife Refuge.

This group broke off from the Darling Foundation and, with Emmy Lou's leadership, became SCCF. Its first priority was the acquisition of certain properties needed to preserve the refuge and freshwater

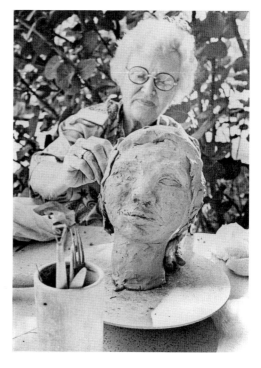

Emmy Lou Lewis. *Courtesy Sanibel Public Library.*

129

wetlands along the Sanibel River. This was the slough of 1833, which had been dredged in some parts to allow the free flow of water. SCCF sought and secured grants of $250,000 to buy this land. By 1976, SCCF owned 207 acres of wooded land along the Sanibel River with more than three miles of nature trails winding through it. The long-awaited nature center was built there in 1977. In 2014, SCCF acquired the Bailey Homestead on Periwinkle Way and has plans to renovate the property and preserve the land surrounding the homestead.

Emmy Lou remained in the guest house on the Nutt property until her death in 1990 from a heart attack. SCCF would never have happened had it not been for the determination of Emmy Lou Lewis.

ANN WINTERBOTHAM

Ann moved to Sanibel in 1964 with no knowledge of native vegetation. Her landscape designer had brought in Australian pines, melaleuca and Brazilian peppers, all harmful to the native environment of Sanibel.

Ann Winterbotham. *Courtesy Sanibel Public Library.*

She decided that something had to be done to popularize the use of native plants. She and artist friend Mada Harrison decided to learn all about native plants and their different varieties. She consulted the scientific papers of George Cooley, who, ten years earlier, had published in *Rhodora, the Journal of the New England Botanical Club*. Armed with this knowledge and determined to inform residents, she displayed plants from around the island at the shell fairs.

In 1973, she and Mada put together an identification book, *Native Trees and Shrubs for Captiva-Sanibel Landscaping*. Mada was the author and Ann, an accomplished wildlife artist, drew the illustrations.

As an advocate for native plants and chairman of the planning commission, she was a force to be reckoned with. Once, when she accompanied a developer to inspect a parcel of land that he'd deemed not to be a wetland, she stepped from the boat into waist-deep water with the fish to prove a point. The parcel was quickly designated a wetland.

Emmy Lou continued to be an advocate for native vegetation. She and her husband, George Campbell, wrote a column for the *Islander* for a number of years that informed the public about native vegetation and wildlife. She and George published a number of books, including *Crocodiles on Sanibel* and *Poisonous Plants of Southwest Florida*. She died in 2012.

SARITA VAN VLECK

Sarita came to Captiva for her health in 1956 and returned for the wildlife. She was a Connecticut native and a Vassar graduate. Plagued with asthma and pneumonia that culminated in a collapsed lung in her senior year, she was forced to take three months off and live with her parents on Captiva.

After receiving her degree in political science, she accepted a position in the ornithology department at the American Museum of Natural History in New York City and later designed exhibits in the Biology of Birds Hall.

Fully recovered from another bout with pneumonia, Sarita returned to spend the winter in her stepmother's cottage on Captiva. "Captiva had no paved roads, few residents and beautiful sunsets. You could walk naked down the beach from 'Tween Waters to the lighthouse carrying only a towel in case you passed another walker."

Sarita Van Vleck. *Photo by author.*

For the next few years, she focused on environmental issues. With development threatening Sanibel and Captiva, she studied ways to preserve the wetland.

In the late 1960s she was part of the newly organized Sanibel-Captiva Conservation Foundation. In the 1970s, she participated in the incorporation of the city of Sanibel, which was modeled after the city of Petaluma, California, the first small town to incorporate in the United States.

Sarita was called to duty to help save Sanibel from overdevelopment. Along with her city planning experience and her conservation beliefs, she was a perfect match for involvement in the incorporation fight. She stated, "It was a time when conservation started coming into the consciousness of the people." The spark erupted into an effort to save Sanibel from destruction in 1967, when an army of bulldozers and dredgers arrived to start clearing land where Periwinkle Way runs into Tarpon Bay: "This flood of instruments of destruction came in and it was so upsetting, but it congealed everybody. The cooperation to save Sanibel took place that winter. Tarpon Bay Road was wrecked, but the city got together and saved it. That was very important."

A small committee was formed, and plans were laid to keep Sanibel special and to incorporate as a city. Sarita recalled the communication process that took place on the island back then: "We went down to the Ferry Landing by the lighthouse, and there was a telephone. And it was patrolled by legions of mosquitoes. Usually there were twenty to thirty people lined up to just to make phone calls. They'd just be standing victims of the mosquitoes. You really had to be committed to this phone call."

Once she decided to move to Captiva full time in 1969, she concentrated on art. With a newly invented Flo-master pen, she drew uninterrupted lines without lifting pen from paper. Her humorous drawings captured the personality of the island's birds. Her more than 650 sketches were put into portfolios and hidden under a futon in her house. Fortunately, she photographed them. After Hurricane Charley, her house and all but 100 of her drawings were destroyed. Sarita still draws, is active on Captiva and has wonderful stories to tell about the early days.

STELLA FARWELL

Stella Farwell was born on June 30, 1939. She grew up in New Orleans, where, in 1960, she was Queen of the Carnival. Her volunteer activities included being a founding member of the Louisiana Nature Center, St. Charles Avenue Committee and Preservation Resource Center. She served on the executive committee of the Junior League of New Orleans.

Stella's business background included serving as vice-president and principal of Exhibit Designers Inc., director of Advertising and Public

Stella Farwell. *Photo by Phil Urion.*

Relations for Solar Power Corporation and president of Energy Alternatives. In 1984, she left the business to pursue an art career.

She moved from New Orleans in 1990 to become a full-time resident of Captiva. Her artwork is in private and corporate collections. It has been displayed in various juried, group and solo exhibitions, as well as in the Madden Museum in Colorado. It has also been featured in local and national publications. Two pieces are in the permanent collection at BIG ARTS in Schein Hall, and the Captiva Civic Association has a piece hanging in its board room.

On the islands, Stella founded the Creativity Program. She was a volunteer firefighter, vice-president of the Island Water Association, president of the Captiva Civic Association, commissioner of the Captiva Fire Control District and the founder of the Captiva History Project.

She was also a member of the board of directors of BIG ARTS and was interior space planning consultant for the new "Ding" Darling education building, as well as a board member of the SCCA Foundation. Her travels included trips to all seven continents and the North and South Poles.

Stella was legendary for her daredevil activities: river rafting, ballooning and jumping out of airplanes. Her trip to the North Pole started in Helsinki, Finland, in July 1998. From there, she flew to Murmansk, Russia, where she boarded a Russian icebreaker and traveled for two weeks until reaching the North Pole. The accommodations about the ship were minimal, mainly for military people and the ice-breaking crew. She found that the North Pole was covered with about twenty feet of ice and is without a stationary marker for the spot, leaving the point of arrival up to the navigational instruments.

Stella's son Tony, an aviator, loaned his mother a handheld navigation device. With her own GPS, she was one of the first to realize the moment they arrived at the North Pole. Before leaving Captiva, she had tucked a Captiva Island flag into her luggage. It now boasts, "This flag was at 90 degrees north with Stella Farwell." The beauty of this icy surrounding impressed her artistic side. After the expedition, she created paper artwork called "Ice on Way to 90 Degrees North." She continued to achieve success with her art and the Captiva History Project until her death in 2014.

Epilogue

The constraints of space do not allow for all those women who made their mark on the history of the islands to be included. Mary Bears Bailey, Anna Woodring, Irene Shanahan, Louise Johnson, Kristie Anders and Marge Meeks are just a few who should also be counted as part of the island's history.

And still there are others today who quietly move about doing their part to preserve the beauty and protect the history of Sanibel and Captiva while making sure that the newest arrivals appreciate the efforts of all, for the historical future of any place is in remembering the lessons of the past.

Following the completion of the newest bridge in 2015, the assault on the pristine beauty of Sanibel and Captiva persists, and women can be counted on to stand guard and speak out.

To learn more about the history of Sanibel and Captiva, visit the Sanibel Historical Museum and Village, the Sanibel Library or the Captiva Library or read my previous book, *Historic Sanibel and Captiva Islands: Tales of Paradise.*

Selected Bibliography

Adams, Frances. "Elinore Dormer Honored." *Sanibel-Captiva Islander*, February 3, 1993.

Anholt, Betty. *Sanibel's Story: Voices & Images from Calusa to Incorporation.* Virginia Beach, VA: Donning Company Publishers, 1998.

Board, Prudy T., and Esther B. Colcord. *Historic Fort Myers.* Virginia Beach, VA: Donning Company Publishers, 1992.

Captiva Civic Association. *Voices from the Past: True Tales of Old Captiva.* Fort Myers, FL: Sutherland Publishing, 1984.

Christman, Linda. "Bailey Brothers Delight Packed Community House." *Sanibel-Captiva Islander*, March 28, 2008.

Coleman, Mary. "Pearl Alice Walker." *Island Reporter*, February 25, 1988.

Dormer, Elinore M. *The Sea Shell Islands: A History of Sanibel and Captiva.* Tallahassee, FL: Rose Printing Company, 1987.

Downes, Jean. "Hallie Matthews." *Island Sun*, April 27, 2001.

———. "Postal Service on Sanibel, a Short History." *Sanibel-Captiva Islander*, March 7, 2002.

———. "Riddle and Crumpler." *Island Sun*, July 13, 2001.

Fritz, Florence. *The Unknown Story of World Famous Sanibel and Captiva (Ybel and Cautivo).* Parson, WV: McClain Printing Company, 1974.

Garrett, Craig. "Human Trafficking." *Island Reporter*, May 10, 2014.

Hackler, Victor. "Florence Fritz." *Island Reporter*, August 10, 1974.

Hill, Yvonne, and Marguerite Jordon. *Images of America: Sanibel Island.* Charleston, SC: Arcadia Publishing, 2008.

Holly, Suzie. "The Mayer Family." *Island Reporter*, July 12, 1983.

Kragos, Mark S. "Chico's Founders Return." *Island Reporter*, November 18, 1994.

Magg, Jeri. *Historic Sanibel and Captiva Islands: Tales of Paradise.* Charleston, SC: The History Press, 2011.

———. "The Little Old Schoolhouse Moves Down the Road." *Sanibel-Captiva Islander*, December 24, 2004.

———. "A Mystical Village on Sanibel." *Ft. Myers Magazine*, March–April, 2003.

Mayor, Ella. "Artist's Whimsical Work." *Captiva Current*, April 30, 2010.

Nelson, Karen. "Fishing in Pine Island Sound." *Sanibel-Captiva Islander*, November 3, 2006.

———. "Ralph Woodring Talks About Fishing—Back Then." *Sanibel-Captiva Islander*, November 3, 2006.

Sanibel-Captiva Islander. "Pirates Playhouse Opens 18th Season." December 29, 1981.

Tabor, Roger. "Adventure, Love and Perseverance." *Island Sun*, July, 28, 2006.

Tuttle, Louise. *The Homes of Old Captiva: A Photographic Record, 1900–1940.* Captiva, FL: Captiva Memorial Library, 1990.

Index

About the Author

Jeri Magg has been freelancing for over thirty years, writing for regional and local magazines and newspapers. She and her husband, Karl, moved from New York to Sanibel in 1980 with their two daughters, Carolyn and Kathy. An avid bike rider and beach addict, she has volunteered at the Sanibel Historical Museum and Village for more than fifteen years and has authored numerous articles about the history of the islands. She published her first book, *Historic Sanibel and Captiva Islands: Tales of Paradise*, in 2011.

Presently a tour guide at the museum, Magg has fielded numerous inquiries about female pioneers and activists on Sanibel and Captiva. Realizing that the history of the islands would not be complete without including women's roles, Jeri decided to write this second book. You can contact her at jerimagg@comcast.net or visit her website, jerimagg.com.

Visit us at
www.historypress.net
..
This title is also available as an e-book